INVISIBLE NEW YORK

Stanley Greenberg

CREATING THE NORTH AMERICAN LANDSCAPE

Gregory Conniff, Bonnie Loyd, Edward K. Muller, David Schuyler
Consulting Editors

George F. Thompson *Series Founder and Director*

Published in cooperation with the Center for American Places,
Harrisonburg, Virginia

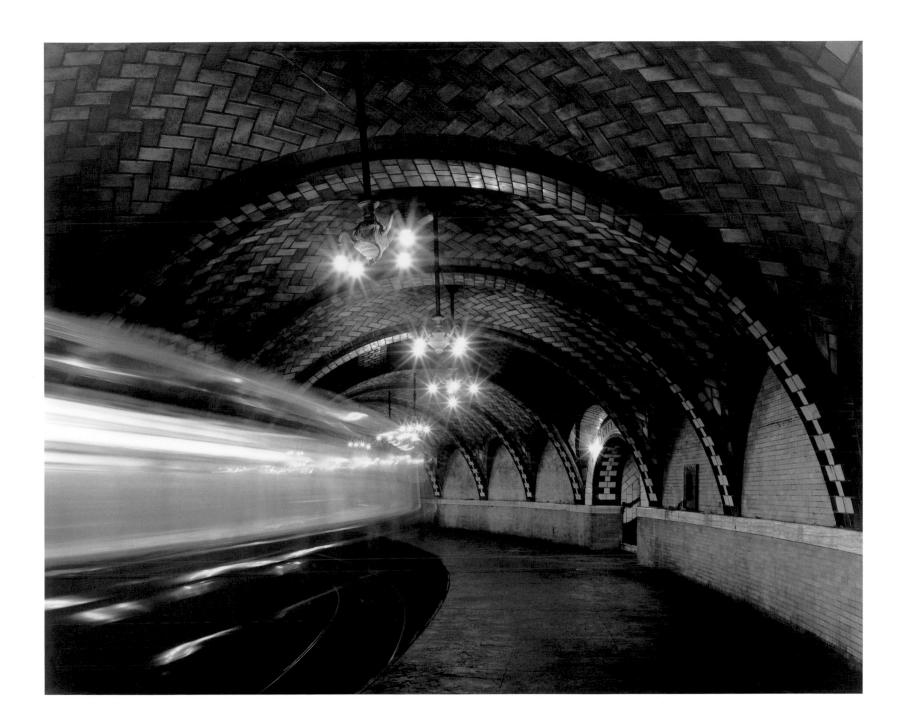

Stanley Greenberg

INVISIBLE NEW YORK
The Hidden Infrastructure of the City

with an introductory essay by Thomas H. Garver

THE JOHNS HOPKINS UNIVERSITY PRESS BALTIMORE AND LONDON

9 8 7 6 5 4 3 2

The Johns Hopkins University Press
2715 North Charles Street
Baltimore, Maryland 21218-4363

www.press.jhu.edu

All prints courtesy of the Yancey Richardson Gallery, New York

Library of Congress Cataloging-in-Publication Data will be found
at the end of the book.
A catalog record for this book is available from the British Library.

ISBN 0-8018-5945-X

CONTENTS

PREFACE

Invisible New York is a photographic survey of the infrastructure that makes life in New York City possible. This infrastructure is vast and in many ways unknown and neglected. Decades of deferred maintenance have taken their toll, and some facilities barely hold together today. Many systems are obsolete or were abandoned for other reasons. Many other facilities are in perfect condition. The people who maintain these places are also part of the infrastructure, although I did not photograph them.

Sites in this book include the anchorages of the Brooklyn, Manhattan, and Verrazano Bridges; old, new, and toxic power stations; Ellis and Roosevelt Islands' hospital ruins; water tunnels 650 feet below the city; a missile base; crumbling piers; and the unseen parts of buildings such as Grand Central Terminal and the Cathedral Church of St. John the Divine.

Photographs of famous places in New York City have been published countless times. I have visited some of those overphotographed places and looked at their hidden parts. I have also been to many lesser-known but equally important components of the infrastructure. Most of my photographs are of inaccessible places, both exteriors and interiors. Some are well known on the outside, others are almost secret. All the photographs were made in black and white with a 4×5 view camera.

Growing up in New York City, I often wondered about many of the places that I eventually photographed. I wanted to know what was

inside the bridges, how the water got here, and what the abandoned buildings on Roosevelt and Ellis Islands were. As a child I saw all the Hudson River piers from the West Side Highway, and then I watched them gradually disappear. I found their remains and photographed them. I read through old guidebooks and histories, searching for forgotten sites. When I photographed, people would ask whether I had ever been to other places that they wanted to see. This helped me find additional sites. Civil servants who were interested in my project took me to places I had never heard of. Although I have not been to every site, I believe I have seen some of the most interesting. I have tracked down many rumors, but some places are still unknown to me. I have heard stories about tunnels that were used by the bootleggers during Prohibition, and I have found manhole covers that may lead to other lost places.

Before becoming a full-time photographer I worked in the New York City government, in agencies as diverse as the Departments of Transportation, Environmental Protection, Parks, and Cultural Affairs, as well as the Mayor's Office of Operations. Once I began this project, I needed all the skills I had acquired working for the city to gain access to the sites. I received permission to photograph each site only after making many requests. In a few cases this process dragged on for four years. Recently it has become nearly impossible to gain access to many of the sites I have photographed, as government officials have become more worried about terrorist acts. Their response has been to make these places more secret. My response has been to make them more visible since I believe that the more we know about the infrastructure, the more we will do to ensure its survival. It is ironic that although our responses have been different, we are all interested in the same goal, namely, preserving the city's infrastructure.

ACKNOWLEDGMENTS

I prefer to work alone. This project, however, gave me the opportunity to work with some wonderful people since I was not permitted to visit most sites by myself. Without the help of those guides and the others who made access possible this book and the pictures in it would not have happened.

I received a great deal of help from the people who oversee the infrastructure covered in this book. I was assisted by Eileen Alter, John Bennett, Michael Cetera, Ted Dowie, Mike Greenberg, Phyllis Kam, Natalie Millner, and Vito Turso, at the Department of Environmental Protection; Frank Addeo, at the Department of Transportation; Jack Lusk, Marcus Book, and Joe Raskin, at the Transit Authority; Kyle McCarthy, at Metro-North Railroad; Pam Harvey, at the National Park Service; Frank Pascual, at the Triborough Bridge and Tunnel Authority; Charles McKinney and Jane Shachat, at Parks & Recreation; Conrad Milster, at Pratt Institute; Alyce Russo, at Roosevelt Island; Bill Logan, at the Cathedral Church of St. John the Divine; Bea Meltzer and Anita Williams, at Con Edison; Paul Wolf, at the Brooklyn Army Terminal; Tom Montvel-Cohen, at the Brooklyn Navy Yard; Diana Pardue and Barry Moreno, at Ellis Island; Tom Antenen, at the Department of Correction; and Marvin Schneider, at the Clocktower.

Several friends helped me research New York City history, check facts, discover sites, and determine the scope of the book: Andrew Brust, Richard Carboni, David Eichenthal, Barbara Kancelbaum,

Margaret Morton, Laura Rosen, Mitchell Schare, Rebecca Shanor, Ellen Spilka, Andrea Sussman, and Robert Tilley. Elizabeth Goldstein has been a great friend and generous patron. John Maggiotto helped with all aspects of the book and life in general.

Tom Garver understood the idea of the book as soon as he saw the pictures, and he wrote a wonderful essay to accompany the pictures. Although a resident of the Midwest, he is a living dictionary of New York City's infrastructure. Tom also helped to ensure that the captions were correct. George F. Thompson, president of the Center for American Places, presented the book project to the Johns Hopkins University Press, assisted in determining the sequence of the photographs, and made sure that it became the book I wanted it to be. I would like to acknowledge the help of everyone at Johns Hopkins Press, especially Doug Armato, Glen Burris, Juliana McCarthy, and Joanne Allen.

Grace Lichtenstein, Wendy Palitz, and John Gertner all helped with publication of my work in *Brooklyn Bridge Magazine*, as did Janet Abrams, in *ID Magazine*.

Joe Rosa, curator, and Dean Bernard Tschumi, at the Columbia University Graduate School of Architecture, Planning and Historic Preservation, Janet Heit and Meridith MacNeal, at the Rotunda Gallery, and Candace Perich arranged for early exhibitions of my work. Professor Kevin Bone and Dean John Hejduk, at the Chanin School of Architecture, Cooper Union, commissioned my work for an exhibition and a publication on New York's waterfront.

The Graham Foundation, the New York State Council on the Arts, and the New York Foundation for the Arts were all very generous in their grants to the project. Richard Solomon, director of the Graham Foundation, and Anne Van Ingen, director of the Architecture, Planning and Design Program at NYSCA, were especially supportive. Rosalie Genevro, director of the Architectural League of New York, agreed to sponsor the NYSCA grant and also helped with other aspects of the book. Jeffrey Hoone, Gary Hesse, and John Freyer, at Light Work, all helped with the final stages of the book. Maria Morris Hambourg, at the Metropolitan Museum of Art, and Barbara Millstein, at the Brooklyn Museum of Art, have been generous with their time and advice. Everyone at Lens and Repro, especially Jeffrey and Steven Kay, Geoffrey Ithen, and George Kondogianis, have always been available to solve technical problems; they have also been great friends.

Sunny and Lloyd Yellen have been extremely supportive from the beginning. My mother, Lenore Greenberg, for as long as I can remember has been willing to provide any help imaginable. My brother David was often willing to visit sites with me and shared the burden of carrying equipment. His understanding of architecture has always been helpful in figuring out how to look at a site. My father, Eugene Greenberg, who died in 1980, taught me how to see and how to photograph. I wish that he had been able to see this book.

Lynn Yellen, my companion, friend, and wife, who has given so much to me, made this book possible in more ways than I can count. My daughter Yelena, who was born after most of the photographs had been made, reminds me every day why I made this book.

S.G.

I wish to acknowledge with warm thanks the assistance of Gregory Conniff and Natasha Nicholson in the preparation of the introductory essay. Greg's pointed questions and comments greatly enriched its content, and Natasha's observations improved the flow and readability.

T.G.

SERVING PLACES

Thomas H. Garver

THE GRAND CANYON IS A PLACE, TIMES SQUARE IS A PLACE, the Brooklyn Bridge is a Place, but Consolidated Edison's Ravenswood Station, a mammoth electrical generating facility in New York City's borough of Queens, is not a Place. It is not a Place because it serves a function we no longer think about as having physical dimensions. We expect the electricity to flow when we flip the switch, and in this technologically sophisticated (and arrogant) time we simply assume that the electricity will be there—and that's enough. Stanley Greenberg's photographs lead us to these unnoted and often invisible places of service. Like Virgil leading Dante through the Underworld, Greenberg takes us to places either hidden beneath our feet or hidden in plain sight by virtue of our very indifference to them. In this journey he makes us aware of the Places where some of the services essential to modern urban life are created, harnessed, and directed.

The title of this introduction comes from one of the important design concepts of the great American architect Louis Kahn. He used "serving" and "served" spaces as important articulating elements in his structures. Of course there are places that house the necessary nonpublic functions of buildings, but the respect for spaces that serve underwent a subtle but profound change when Kahn replaced the word *service* with the more active and coequal *serving*. Kahn's reference elevated one function—serving—closer to the level of the other—being served. A similar motivation informs Greenberg's photographs: They record and make manifest serving places by equating the function of serving with the recognition of *place*.

Writers have twitted Americans almost since the inception of the country about their pragmatic desires for practical results, which took precedence over more lofty ambitions. In 1835, for example, Alexis de Tocqueville made the observation, since frequently quoted, that Americans "will habitually prefer the useful to the beautiful and they will require that the beautiful should be useful." Of course utility had to take precedence over beauty as the country shaped its infrastructure, which was far more vast than any European prototype, while at the same time accommodating an expanding population. But beauty was not to be neglected. America's public services were essential to the country's mandate for growth, and its citizens came to deeply respect them. This ability to provide pure water (and later gas and electricity) and to whisk effluent to places beyond the reach of one's senses came to be memorialized in buildings that were often beautiful as well as useful. These structures were worthy expenditures, whether from the private or the public purse, because they marked human efforts put to the highest common purpose. Shining machinery filled these temples. They were places that warranted a visit, sites where one might consider the finite accomplishments of a temporal world. They offered an experience parallel to a quiet stroll through one of the

country's picturesque rural cemeteries filled with splendid funerary monuments, suggesting the infinite and the Almighty. In both the structures of technology and the structures of the hereafter Americans expressed their values in stone, and built them to last.

Now it would seem that we want to attenuate these marks of personal transition and public achievement. Death no longer seems to warrant the creation of proud physical monuments, no matter how intensely felt the loss may be. Most contemporary cemeteries have become open parks, kept free of monuments for easier maintenance, while the network of modern infrastructure systems and manufacturing plants are constructed anonymously and uniformly (if not inexpensively). Certainly some great icons of technology still thrill us: the Golden Gate and Brooklyn Bridges and Hoover Dam, for example. But few great civic constructions of the last fifty years command the respect and awe that their earlier counterparts did. Stanley Greenberg's photographs imply that contemporary Americans have lost their interest in the serving places of less than iconic stature. They ignore much of what their forebears built so solidly: The maintenance of these facilities is now minimized or deferred. Cities that once marked advancement by structures built for the commonweal—majestic bridges, waterworks, museums, civic centers, public libraries—now pride themselves on their success in capturing and retaining professional sports franchises and eagerly use public money to construct arenas for the enrichment of privately owned teams.

The changes that have taken place in America's industrial and utilitarian methodologies may explain why Americans' perceptions of and regard for "serving places" have changed so profoundly. The typical large nineteenth-century factory would have been made up of closely built, multistory, solid brick structures surmounted by the belching smokestacks of the power plant. Smoke meant business, and pollution meant progress. The internal functions of buildings of commerce and utility were reflected by their exteriors. One could immediately differentiate between a power plant and a brewery, for example. The factories of today are dressed in windowless aluminum or cast concrete, created in standard modules to fit every size, anony-

mous additions to the industrial "parks" that ring almost every urban area. Heavy industrial activity is no longer one of the characteristics of a great city, and physical labor itself is now regarded with some embarrassment. The elimination of mills and factories, once so essential to urban life, is hailed as a great modern advance. In many urban areas industrial activity has been supplanted by theme parks, some of which offer a simulacrum of a demolished past or a speculative future; entertainment, in all its forms, has become the measure of human achievement. The products must still be made, the power generated, the water pumped, and the sewage treated, but let it be done elsewhere, and invisibly.

The disconnection from our places of service is furthered by growing doubts about the sustainability of America's technological achievements. Our water, which we once saluted for its unrivaled purity and propitiated with splendid water towers and graceful dams (plates 24 and 34), now seems to contain the specter of lurking microbes and toxins. The electricity on which our cities must continuously feed has failed, plunging us not only into darkness but into social chaos as well. The steel ribbons of the railways are riddled with hidden flaws, bridges collapse without warning, and airplanes inexplicably fall from the sky. There would seem to be a growing desire to turn away and just ignore these things. But in that act of turning away we may be fulfilling a subtle and cunning Mephistophelian bargain. This time it takes the form of the digital transubstantiation of our physical existence, the conversion of our lives from a state of reality to a state of virtual reality, transfixing us before the magic screen— Netscape trying to replace Landscape. Possessed of the quantum magic that will take humankind anywhere, can we speculate that there is no longer need of the bulky structures and grating mechanisms of the Newtonian past? But to banish them is to banish memory, individuality, and place. One is anonymous on the Internet, and anonymity discourages responsibility and public behavior. More fundamentally, one is placeless in cyberspace, a location as insubstantial as the nature of its reality. When the power is off, Gertrude Stein's observation that "there is no there, there" becomes piercingly true.

In considering this future and recognizing the importance of the fixed places of our technological past—and present—Stanley Greenberg has created an ongoing cycle of photographs about these "invisible places." Although the sites are all located in the New York City metropolitan area, the images are not restricted to any specific place or activity. They cover a broad sweep of time and offer a silent documentation of how serving places have changed and how we have changed our perceptions of technology and technological places. The earlier structures pictured in this book (e.g., plates 31 and 32) possess a more "humanistic" quality in that even substantial civil engineering projects resembled, in fundamental ways, what might be thought of as domestic architecture. This may be due in part to the construction technologies employed: brick and ashlar masonry, which were also the principal building materials of the residential city at the time, while windows, generously used and scaled to human use, flooded the interiors with natural light. As a result, we may find these structures easier to warm to than later and even more monumental ones, which do not offer the same dimensional forms and are without the latent attachment to home. Surely the early buildings for the control of water demonstrate this domestic affinity, with the best of these structures suggesting fragments of a Romanesque fortification or Renaissance villa transplanted to the suburbs of New York City. Greenberg also documents later forms of water control. The valve chamber of City Tunnel No. 3, in particular (plates 2, 4, and 6), is almost anti-architectural, for it is located hundreds of feet beneath the Bronx. Designed during the Cold War and calculated to resist even a direct nuclear blast, it is awesome but not warming, built, it would seem, to be efficient and invisible. Far from any bomb and truly hidden from sight, this remarkable achievement of design and construction reflects a new urban attitude. Instead of being the proud and visible symbol of ongoing improvements for all Americans, this massive undertaking is regarded by its administrators rather like civic underwear. It is utilitarian, and certainly necessary if a city is to be properly outfitted; it is an embellishment to public services but not to public places. In this regard engineers are in perfect compliance with most Americans' wishes to know nothing about their utilities. These are activities that modern techno-bureaucrats, assisted by engineers and architects, have decided are best left unobserved. And as Stanley Greenberg discovered, his attempts to visit these places to make photographs or even to express his sincere appreciation for them were often regarded with the suspicion and apprehension that one might expect to be directed at a voyeur or a terrorist—but not an artist.

The most intense images of Stanley Greenberg's historical record are the ones that many of us may least wish to see. These are the photographs of the ruins of our technological past (e.g., plates 38 and 40). Such places, once busy but now dead and empty, exist in almost every American city of any age. We refuse to acknowledge them, and their existence slips beneath our vision. We cannot abide to see the technological wreckage in our own cities, preferring instead to emulate our ancestors and travel vast distances to see ruins of a more noble sort: Ankor Wat, Karnak, Chichen Itza, Mesa Verde, Athens, or Rome. Ruins should be a vehicle for contemplation of the longevity and achievements of human society. How can it be that the ruins of our age, these massive and modern constructions, are suddenly reduced to nothing more than junk? Greenberg leads us to these sites and makes us look at the documents of the forced march of technology; his photographs raise necessary questions not only about technological obsolescence but also about the roles civic responsibility and corporate culpability have played in the creation of such places.

Stanley Greenberg has also looked at serving places more intimately, bringing his 4 × 5 view camera closely to bear on these places and the machines that fill them. Consider his images of two vastly different electrical generating plants. The first is located at the Pratt Institute in Brooklyn (plate 49). Fitted with its present machinery in 1900, it is almost the sole remaining example of a functioning independent electric plant of the sort that at one time numbered in the thousands in America. This is a place of human scale, a space hardly larger than a big living room or small gymnasium, in which textures predominate. Brass railings protect the polished steel parts of the steam reciprocating engines, and the dull gleam of heavy

bronze-framed gauges punctuates the marble of the switchboard. The space these machines occupy and the articulations by which they operate are clear and understandable. The second image, made at Consolidated Edison's Ravenswood Station (plate 47), contains a giant turbine generator half imbedded in the floor, like a mammoth hippopotamus at river's edge. The size and scale of this machine (and this plant) are huge, but the texture and articulation of the earlier machines is gone. We sense the power, but whether it is running or still this monstrous machine never changes in appearance. The Ravenswood Station is a landmark because it houses the biggest steam generating equipment ever built, but it is likely that the little plant in Brooklyn may be the more memorable, for it simply offers more nourishment to the senses. It is the shift of these sensate and "aesthetic" elements that mark one of the sea changes in serving places of the late nineteenth and the twentieth century.

One of Greenberg's pleasures—perhaps in homage to earlier photographers who approached the documentation of great civil construction projects straight on, with respect and appreciation, not with a sense of superiority or irony—is setting up his camera on axis with long vistas. The result is a body of photographs that peer into deep space, usually surrounded by powerful structural framing element of stone, steel, or concrete. More than a century separates two of the underground constructions he has recorded for this book. The service tunnel under the great valves of City Tunnel No. 3 (plate 2) offers the more expansive vista. It is 250 feet below Van Cortlandt Park, in the Bronx, but its smooth concrete surfaces give no clue of that. This is a place made by machines, a place that is awesome and cool, efficient and distant. The earlier space is a vaulted chamber under the abutments of the Brooklyn Bridge, an unseen part of a heroic structure (plate 1). Somehow it better conveys the idea of "underground" to us, perhaps because it was built in collaboration with the bedrock rather than by blasting it out of the way and replacing it with concrete. The walls of this room are constructed from this stone, and the barrel vault above is a richly textured example of structural brick masonry, a wonderful builders' art that concrete long ago rendered obsolete.

Two other axial images further demonstrate the changes that monolithic concrete and steel plate construction have made in an earlier building methodology in which smaller elements were used to form complex structures. The steel columns and knee braces of the Brooklyn Army Terminal Pier form a dense angular network that frames and shapes the long central service passage along the pier (plate 45). This is a muscular place, and one is constantly reminded of that by the insistent structure, a canopy of steel that hovers overhead and on all sides. Greenberg's axial photo of the Staten Island anchorage chamber of the Verrazano-Narrows Bridge, constructed about fifty years later, is curiously flat (plate 10). Although another view of this room, taken at right angles to this one (plate 12), does show the remarkable tensile web of the cable attachments, the room itself is bland and all but uninflected. In both images what first draws our attention is not the great harp of the cable anchorages but the tatty, untidy surroundings that mark its use as a storeroom for maintenance supplies. Modern engineering has replaced the laying of brick upon brick or stone upon stone with a technology whose visual power fails to match its structural sophistication.

Stanley Greenberg offers an answer to the question, What makes a *place*? In his photographs a place is a physical location of human creation and human activity, constructed to serve a specific function, which it may or may not still do. The place possesses a powerful form, and no matter how much it may have deteriorated, it offers a strong appeal to the senses. Although Greenberg's places are built by human hands, there are no people in them to cloud their geometry. Greenberg's view of serving places is expansive and cool, but it is not distanced from his sometimes gritty subjects, for the work is undergirded by passion and concern. He has worried that "little by little, we are letting our cities fall apart and it's much easier to let the hidden parts, essential though they may be, fall apart because no one can see what's happening. While many of the sites I've photographed are in good working order and are maintained by committed civil servants, the resources are not there to keep them that way. These places are fascinating to me in any condition, but I'm not sure how much longer

they will be around." His is an important record, for as working places they are disappearing or being changed: renovated or modernized without reprieve.

Let one final image, the one that all but closes the photographic sequence of this book (plate 51), stand for the places that Stanley Greenberg has photographed. This small room is the scene of intense activity, a central dispatch point for New York City's subway trains. Switch levers cover a console along one wall of the room. The levers are pulled or pushed to change the switches, while lights indicating individual switch positions change on the board above. The steel handles, polished by decades of human touch, have been designed carefully to fit the hand, and touching the cool metal brings one into direct contact with the switches out in the yard. When Greenberg photographed here, he was told that this was one of the last such manual switch consoles left in the New York subway system, most of the others having been converted to an automatic button operation. This is the "old-fashioned" switching system, in which grasping a metal handle immediately tells one something about the position of the switch below. For the present, this activity remains a physical one, and one quite different, say, from setting a microwave or changing channels on the television. Its replacement will require only that a button be pressed. This job will thus be seamlessly melded into the ongoing experiences of modern work, contemporary food preparation, and entertainment. The press of a button may vastly increase our reach, but in the process we will lose a whole range of rich and varied sensate experiences.

PHOTOGRAPHS

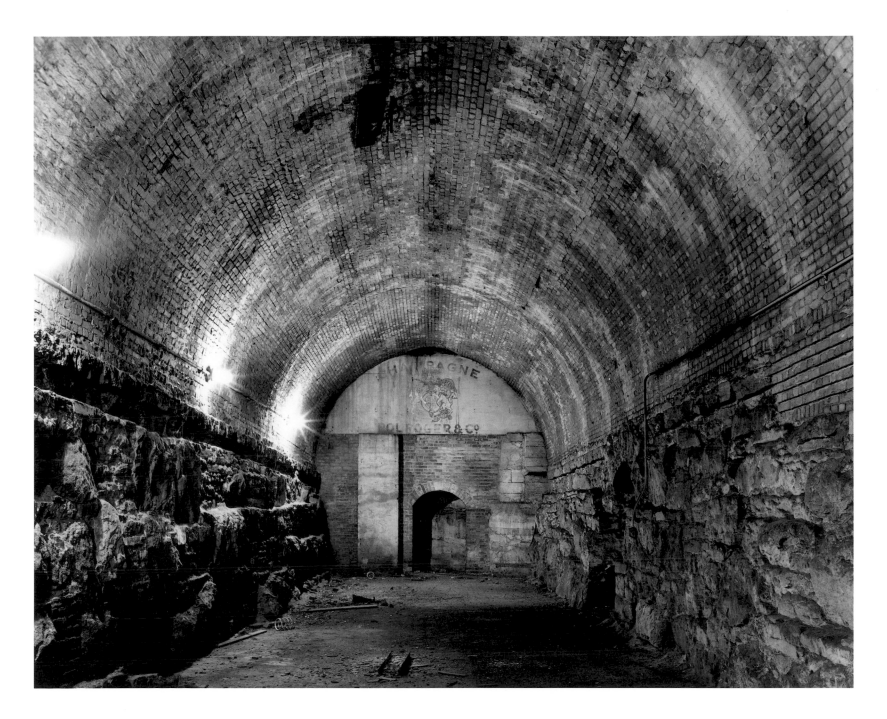

PLATE 1 Wine Cellar, Brooklyn Bridge, Manhattan, 1992

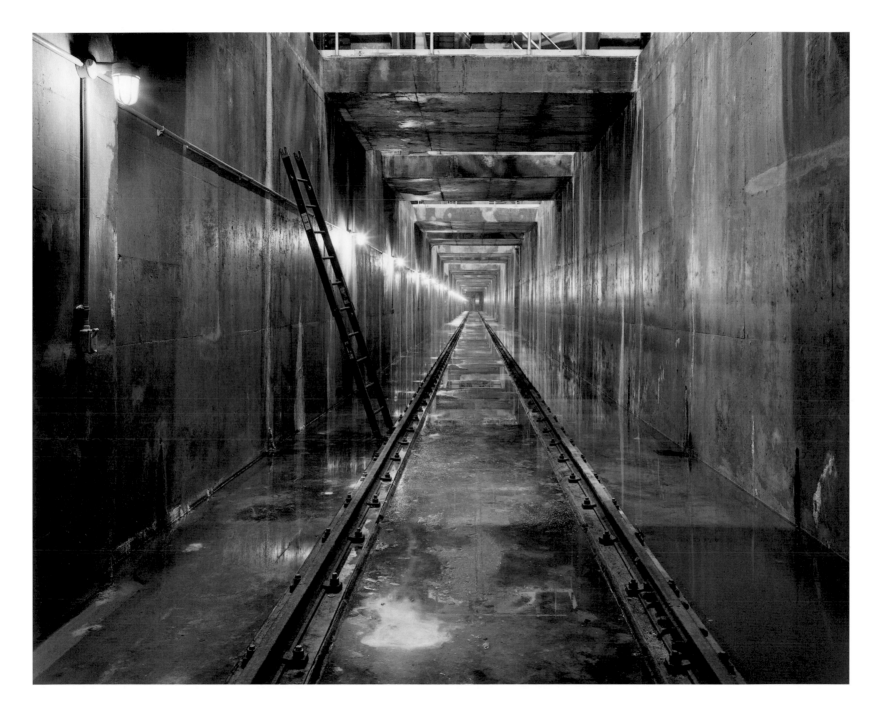

PLATE 2 Maintenance Tunnel, Valve Chamber, Shaft 2B, City Tunnel No. 3, Bronx, 1992

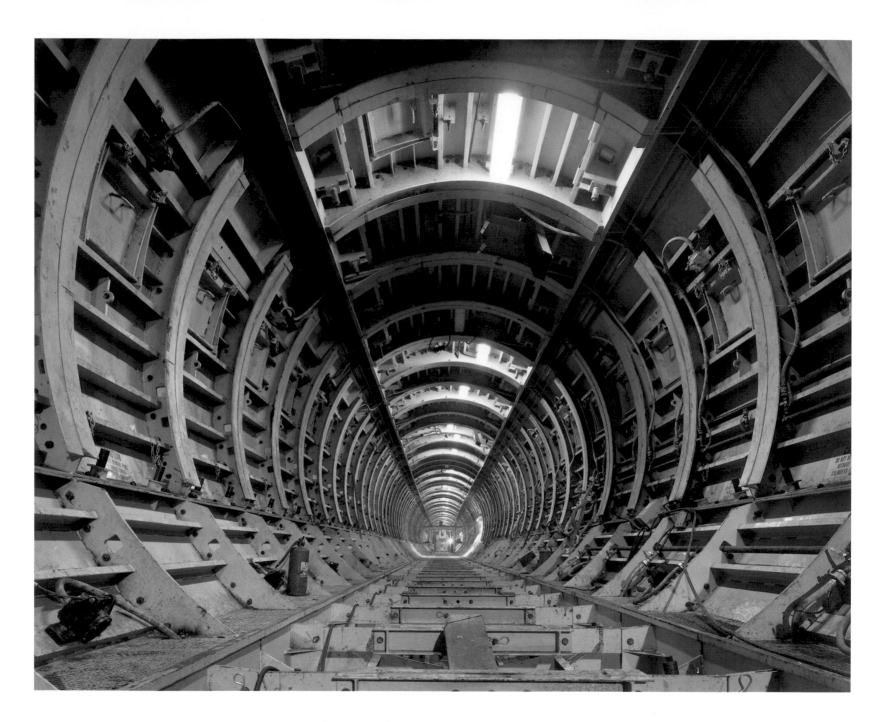

PLATE 3 Construction Site, Shaft 19B, City Tunnel No. 3, Queens, 1997

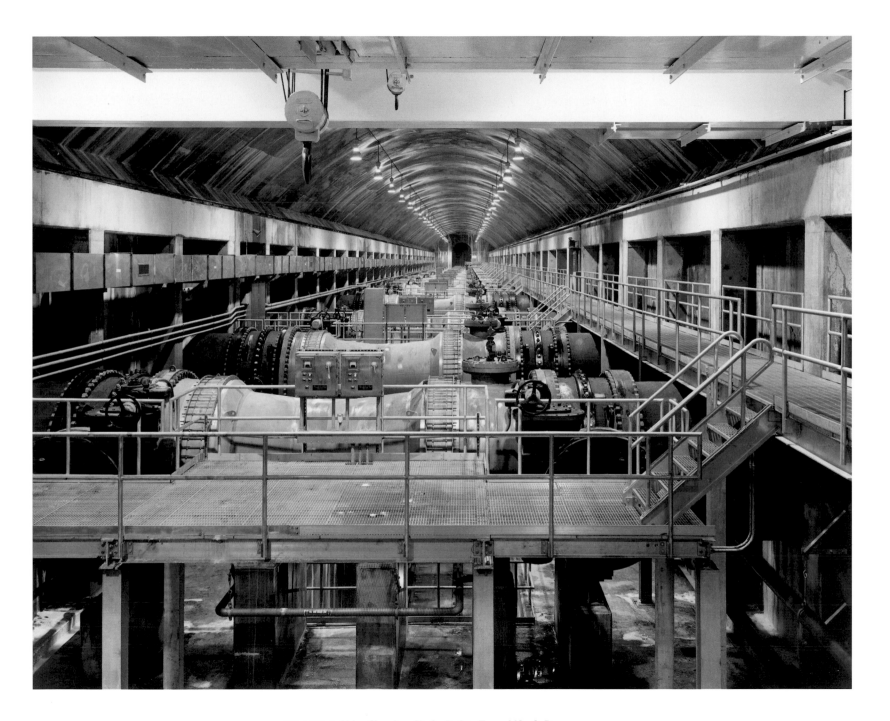

PLATE 4 Valve Chamber, Shaft 2B, City Tunnel No. 3, Bronx, 1992

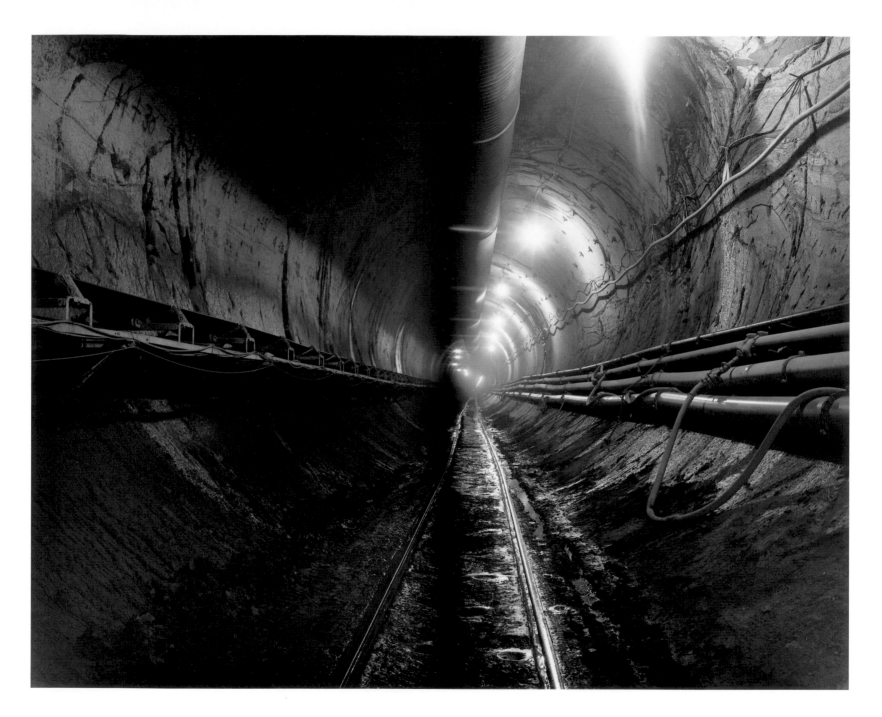

PLATE 5 Construction Site, Shaft 19B, City Tunnel No. 3, Queens, 1997

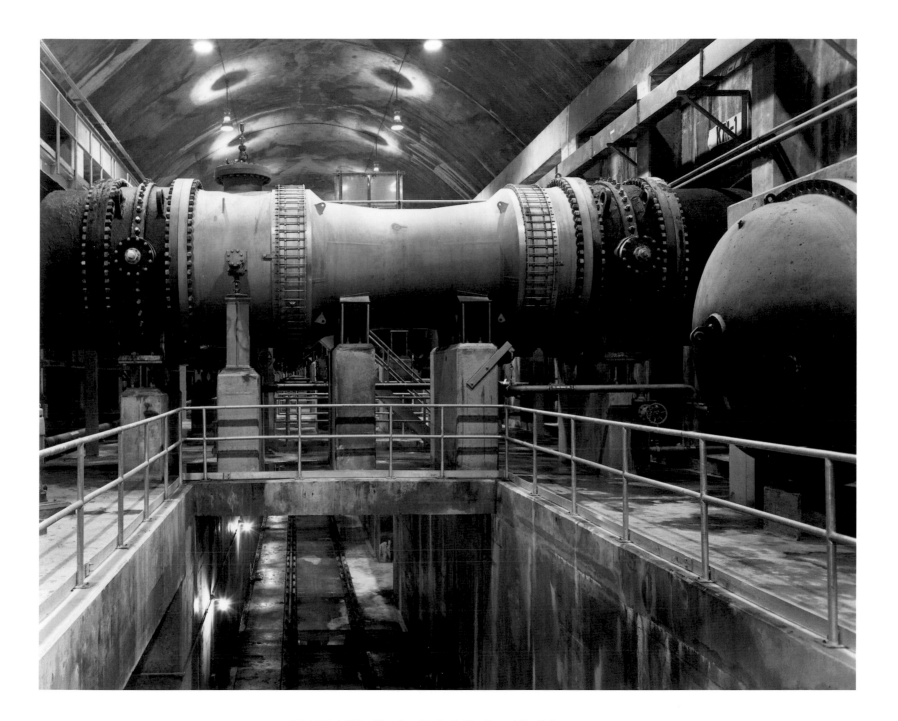

PLATE 6 Valve Chamber, Shaft 2B, City Tunnel No. 3, Bronx, 1992

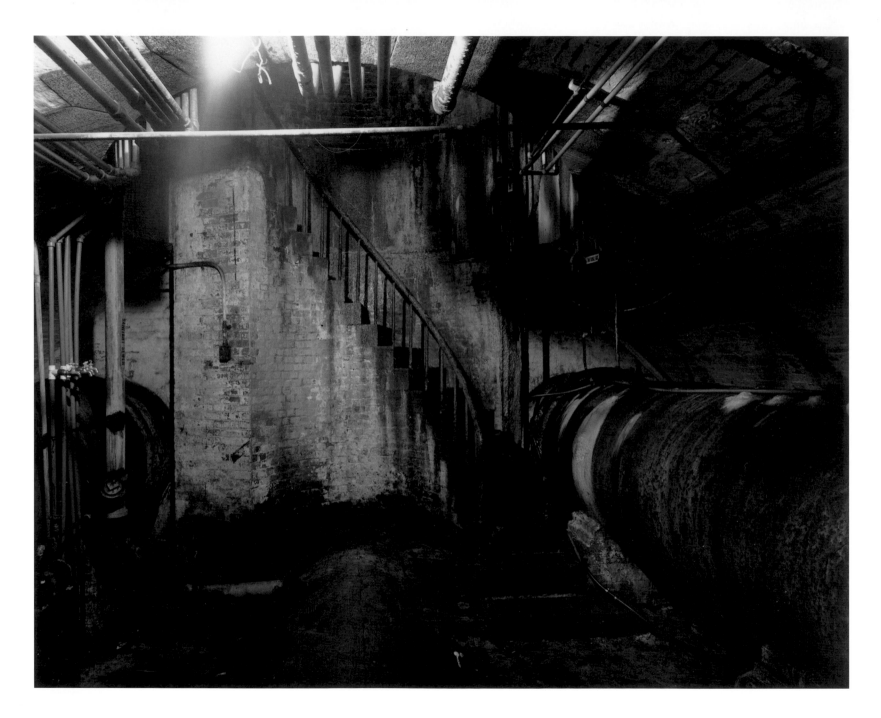

PLATE 7 Reservoir Gatehouse, Central Park, 1996

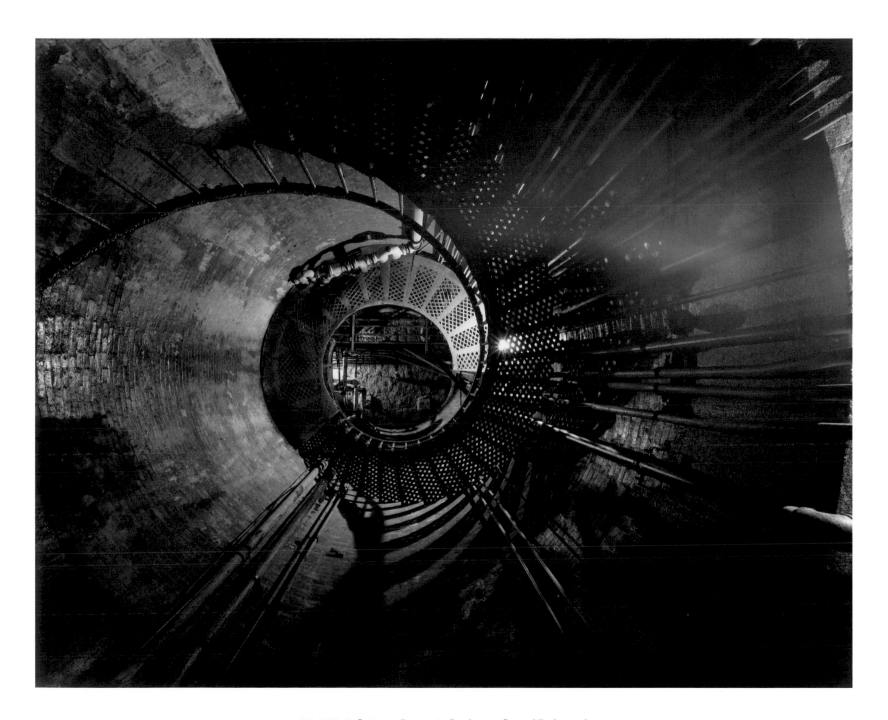

PLATE 8 Stairway, Reservoir Gatehouse, Central Park, 1996

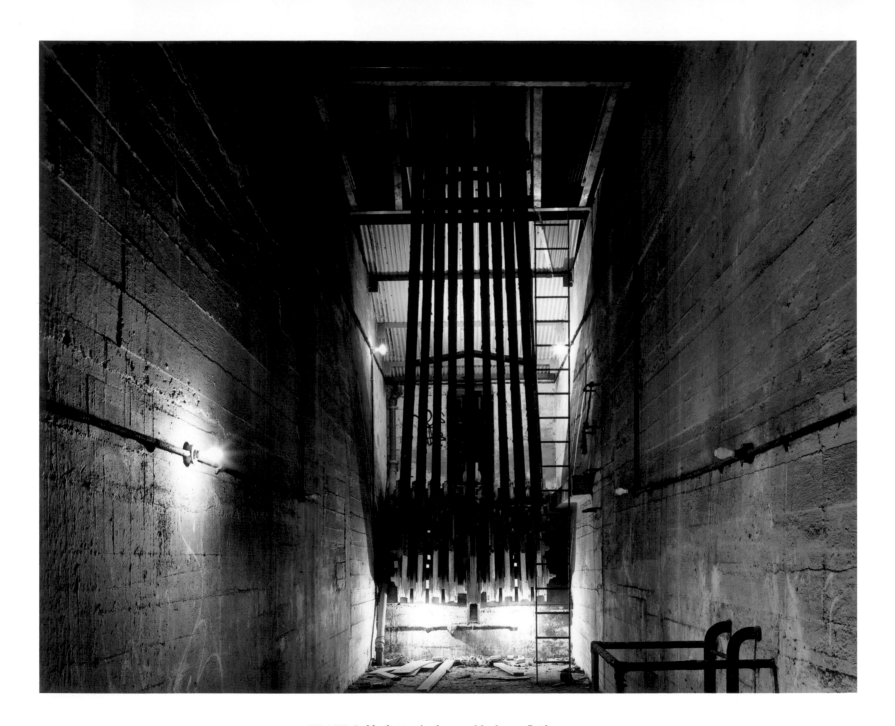

PLATE 9 Manhattan Anchorage, Manhattan Bridge, 1992

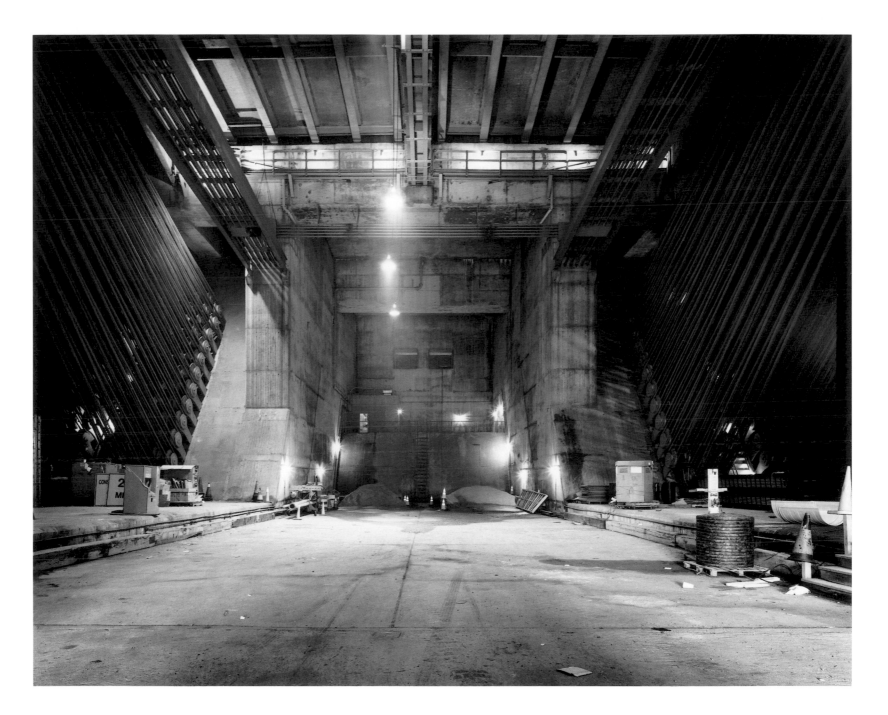

PLATE 10 Staten Island Anchorage, Verrazano-Narrows Bridge, 1992

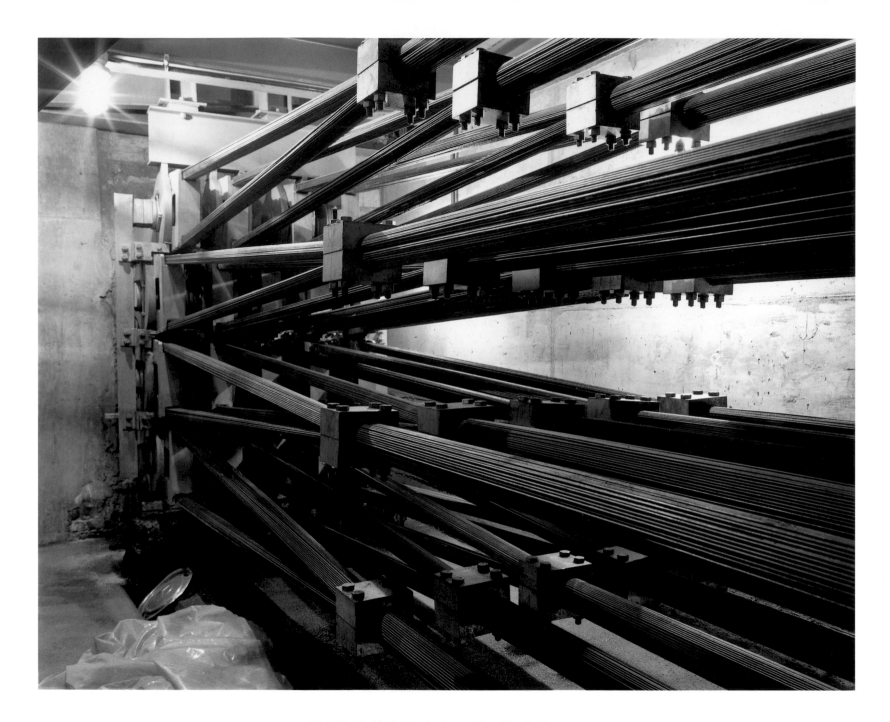

PLATE 11 Manhattan Anchorage, Brooklyn Bridge, 1992

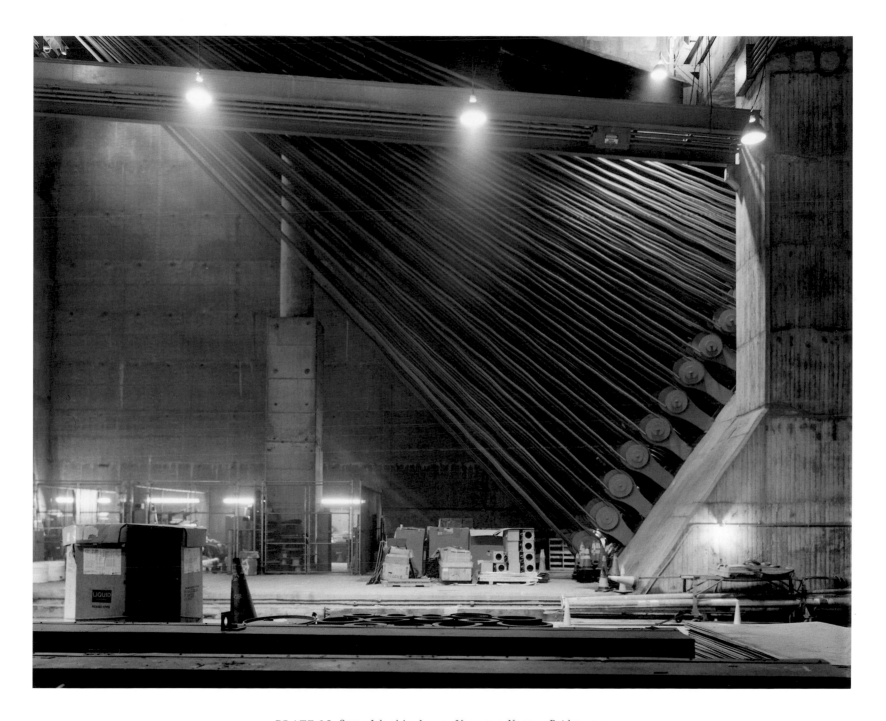

PLATE 12 Staten Island Anchorage, Verrazano-Narrows Bridge, 1992

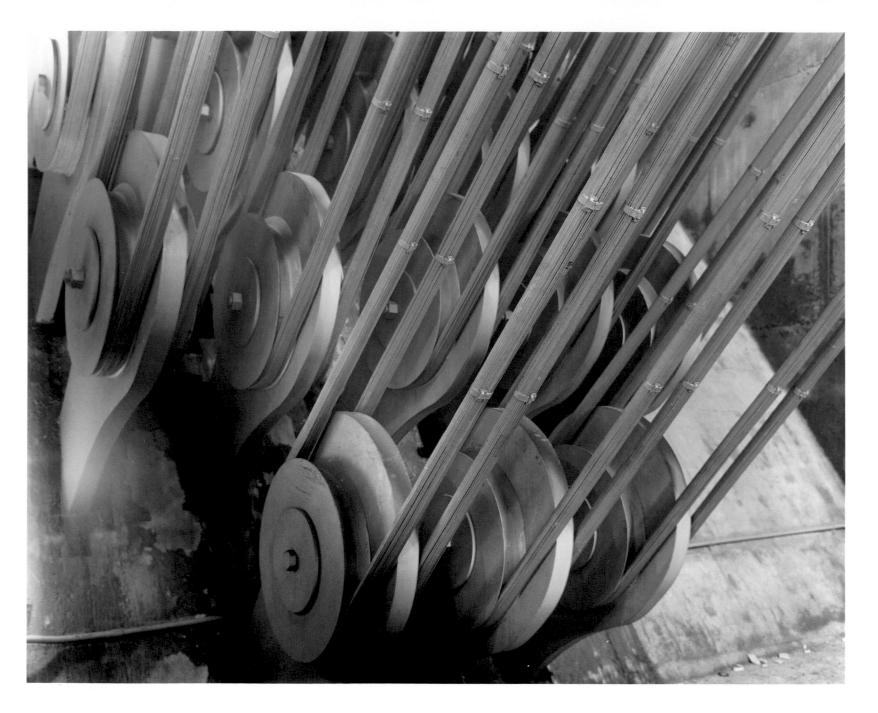

PLATE 13 Staten Island Anchorage, Verrazano-Narrows Bridge, 1992

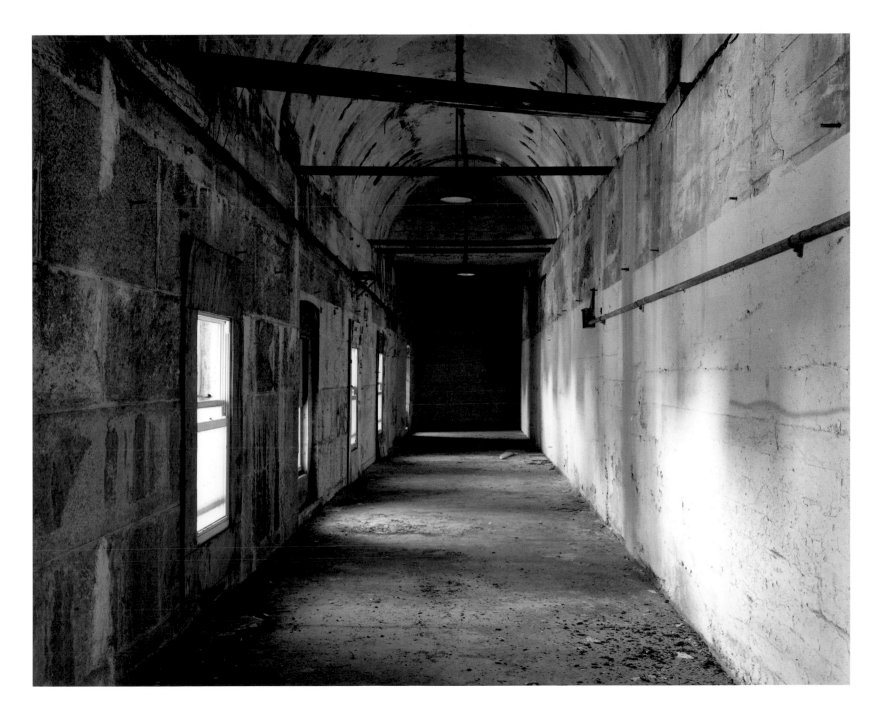

PLATE 14 Manhattan Gallery, Manhattan Bridge, 1992

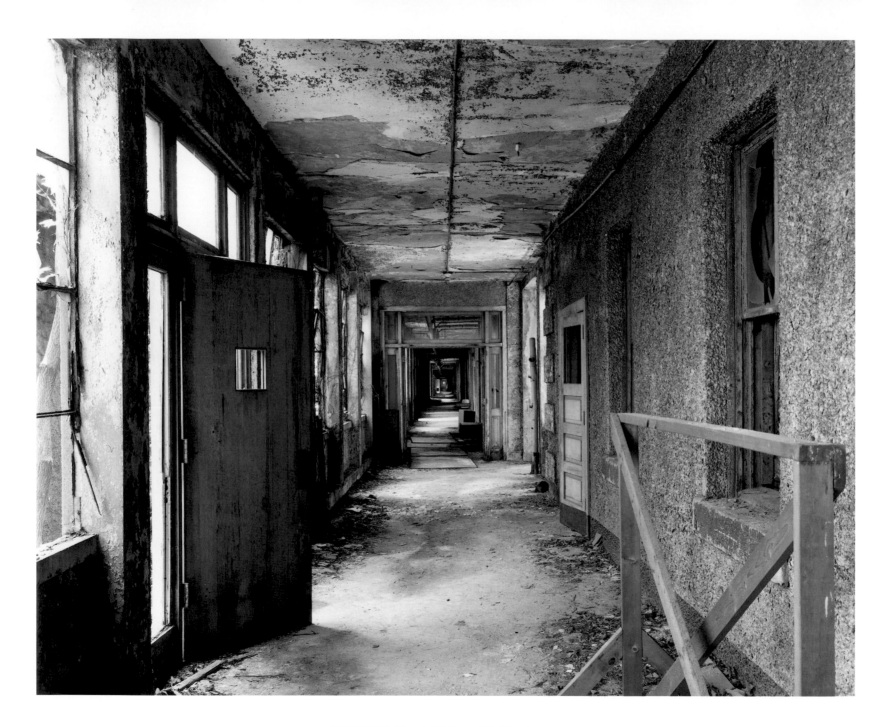

PLATE 15 Hospital Hallway, Ellis Island, 1992

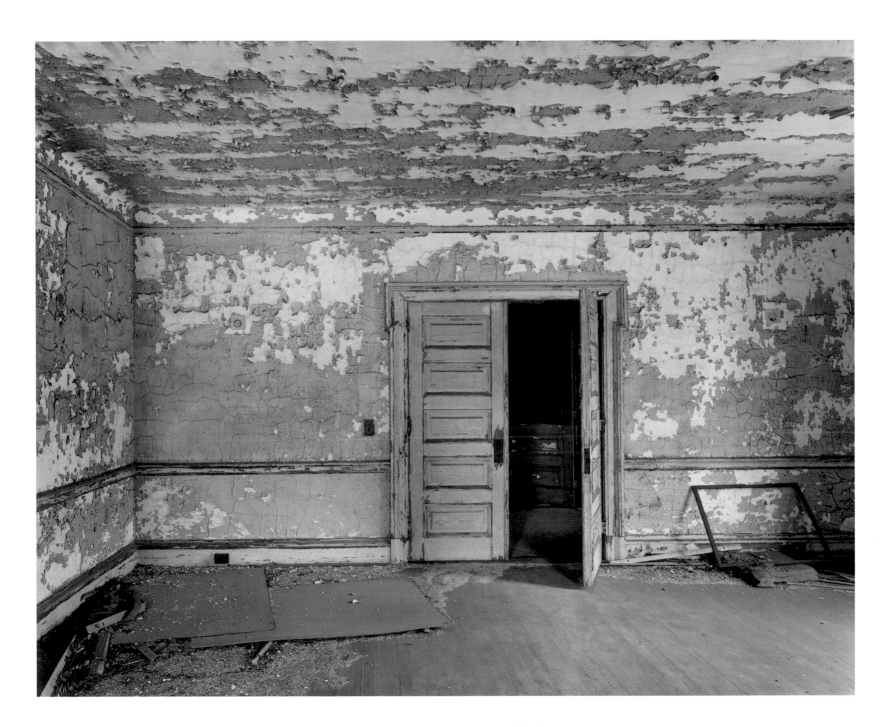

PLATE 16 Hospital Staff House, Ellis Island, 1992

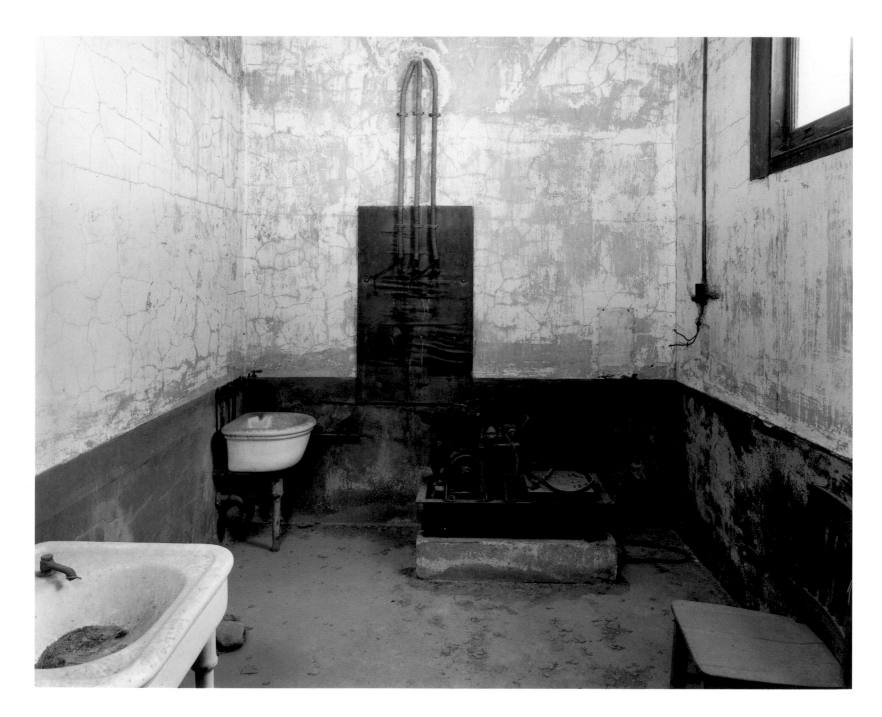

PLATE 17 Morgue Preparation Room, Ellis Island Hospital, 1992

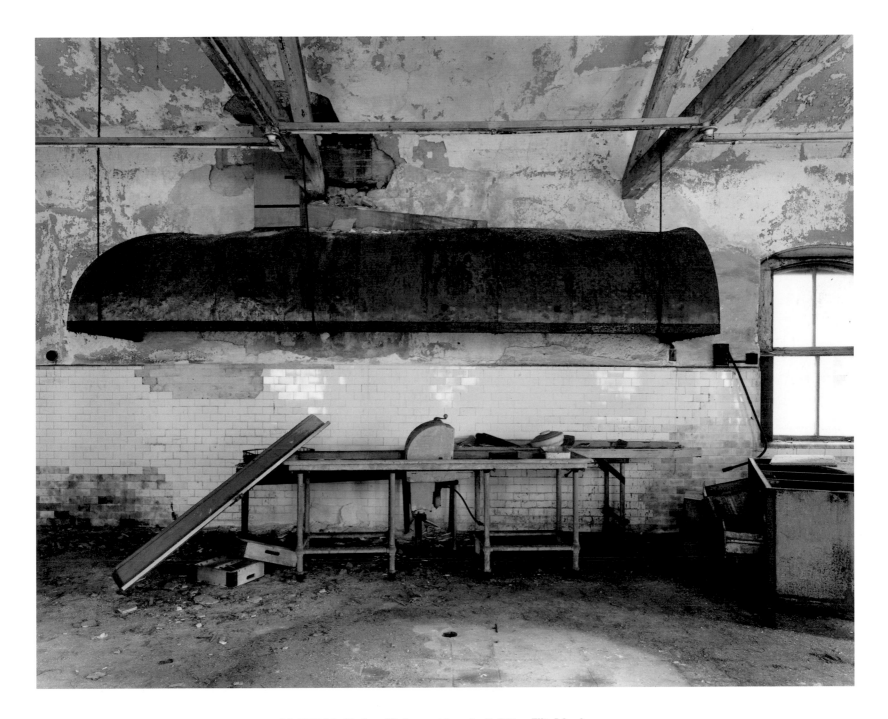

PLATE 18 Kitchen, Kitchen and Laundry Building, Ellis Island, 1992

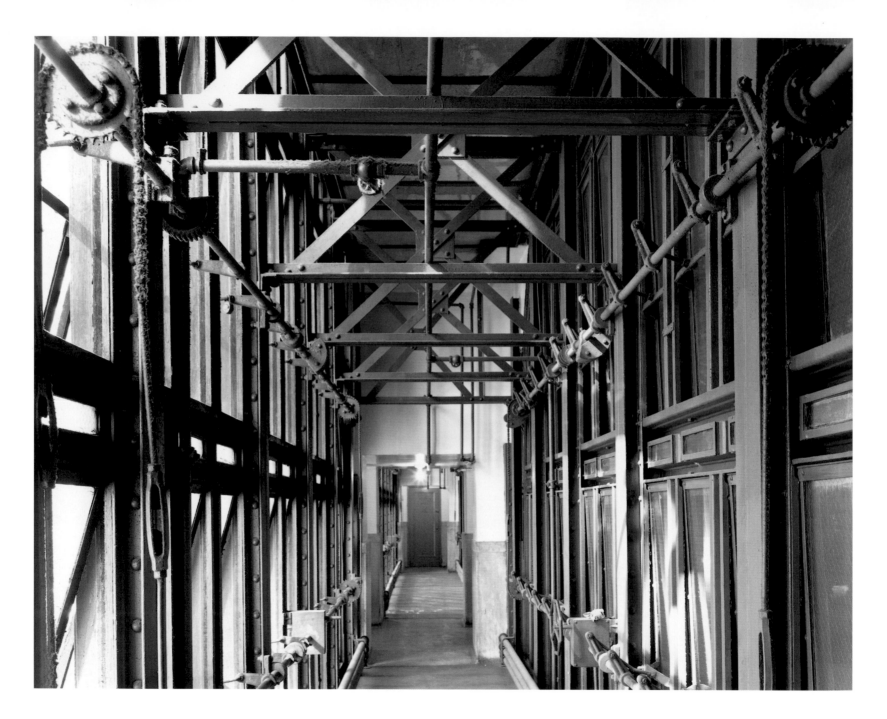

PLATE 19 Catwalk, Grand Central Terminal, 1993

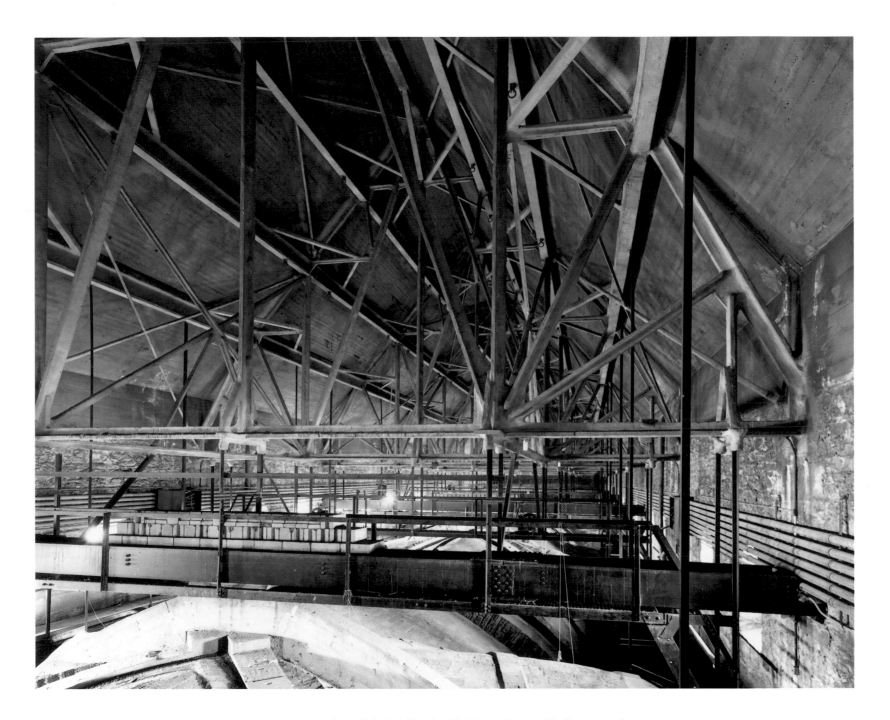

PLATE 20 Attic, Cathedral Church of St. John the Divine, Manhattan, 1993

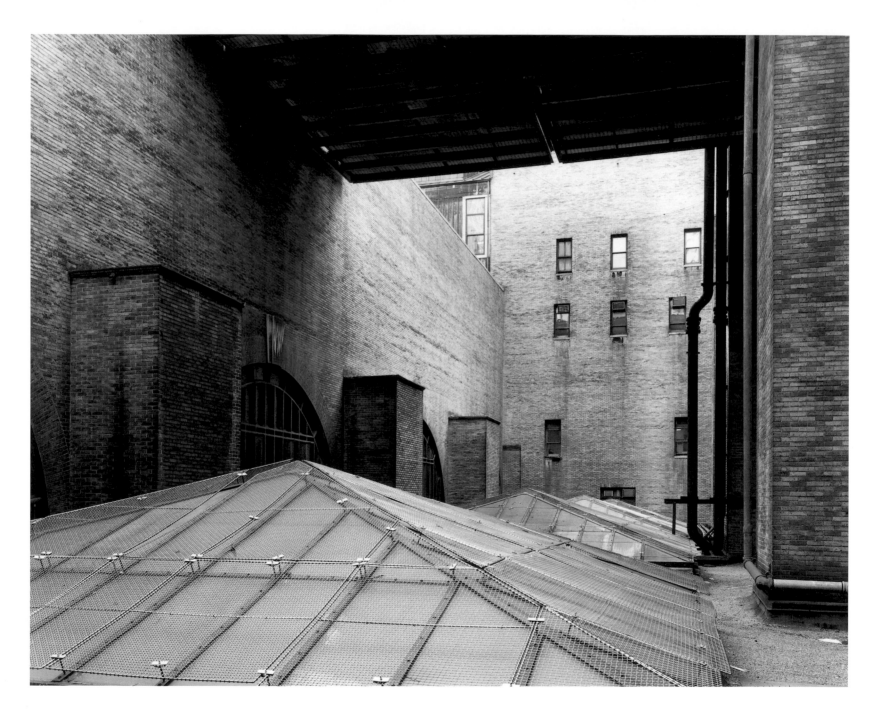

PLATE 21 Roof, Grand Central Terminal, 1993

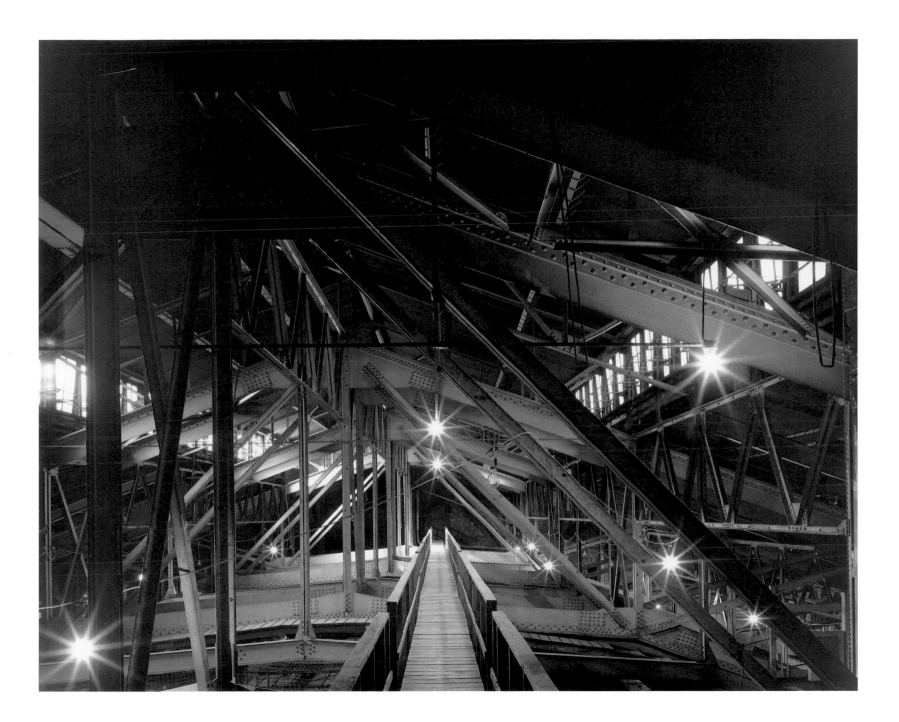

PLATE 22 Attic, Grand Central Terminal, 1993

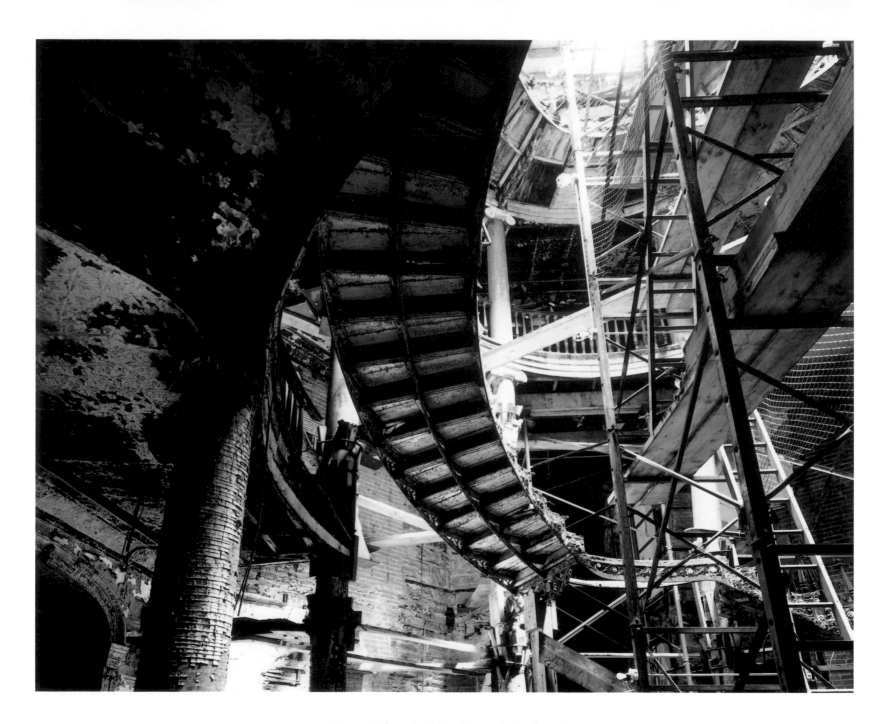

PLATE 23 Lunatic Asylum, Roosevelt Island, 1993

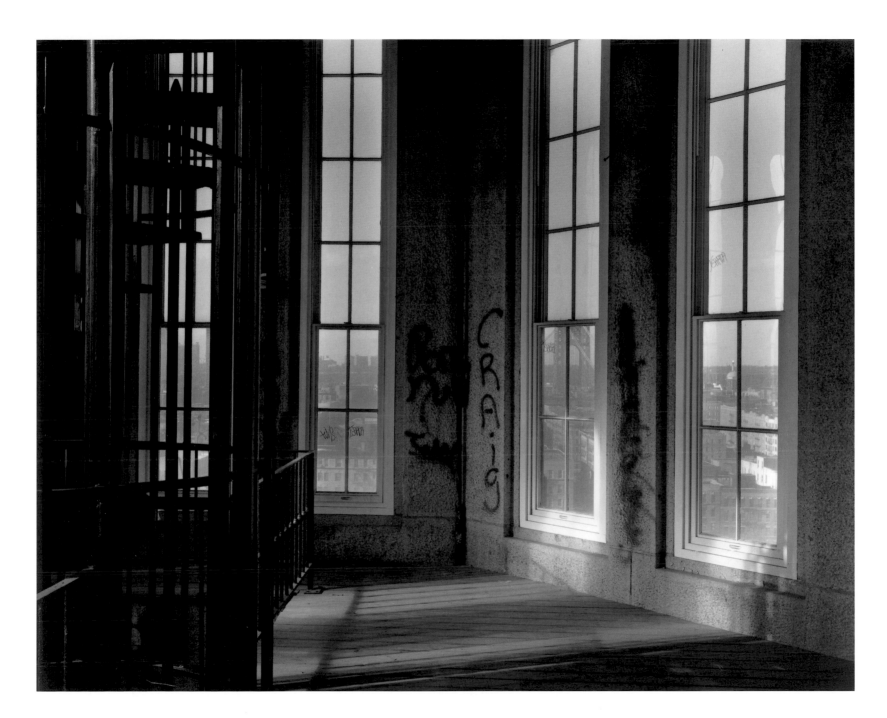

PLATE 24 Interior, High Bridge Tower, Manhattan, 1995

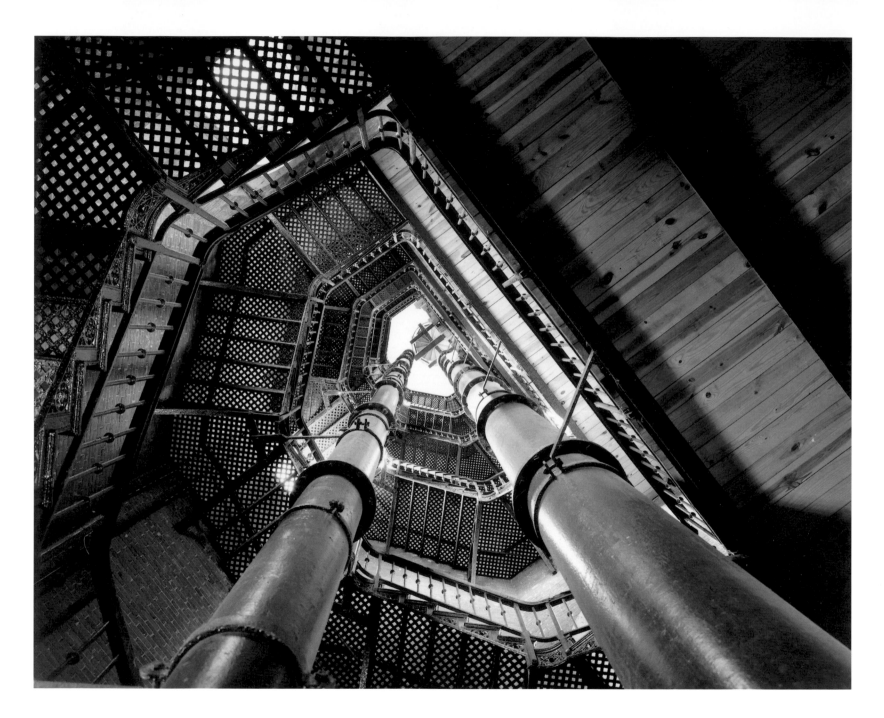

PLATE 25 Interior, High Bridge Tower, Manhattan, 1995

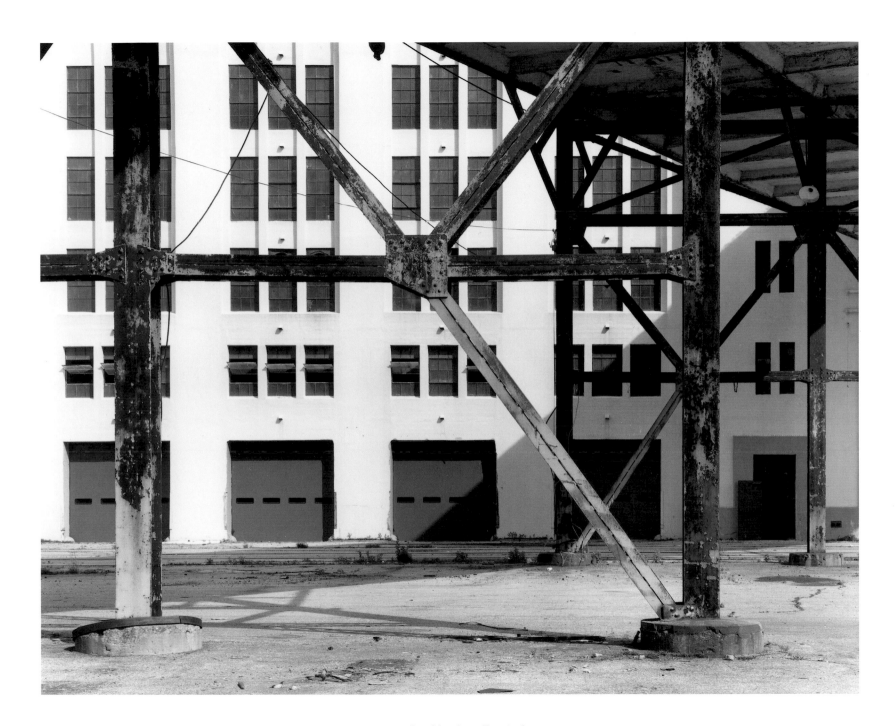

PLATE 26 Brooklyn Army Terminal, 1994

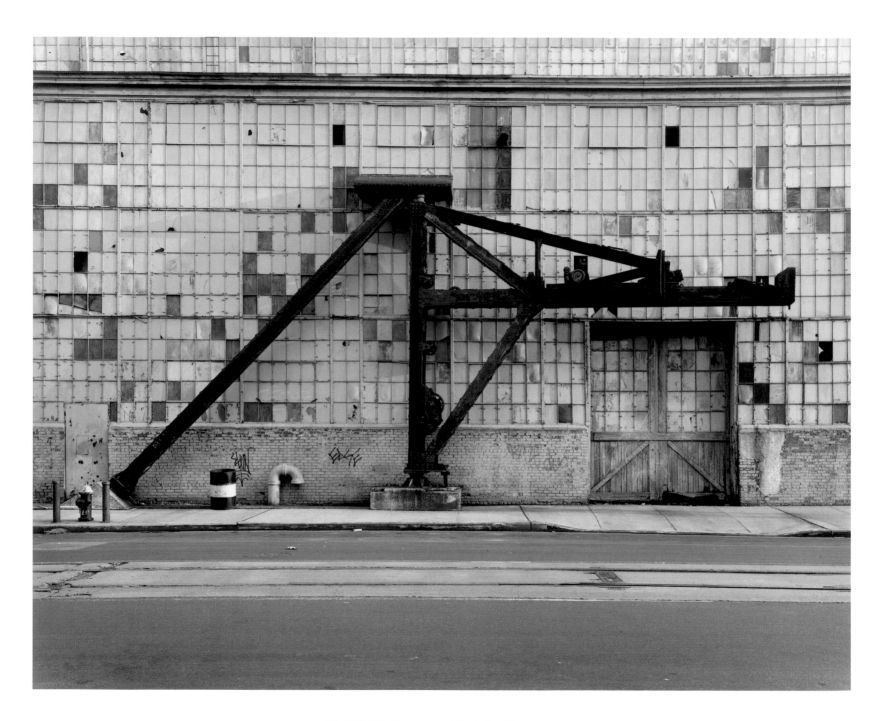

PLATE 27 Crane, Sunset Park, Brooklyn, 1990

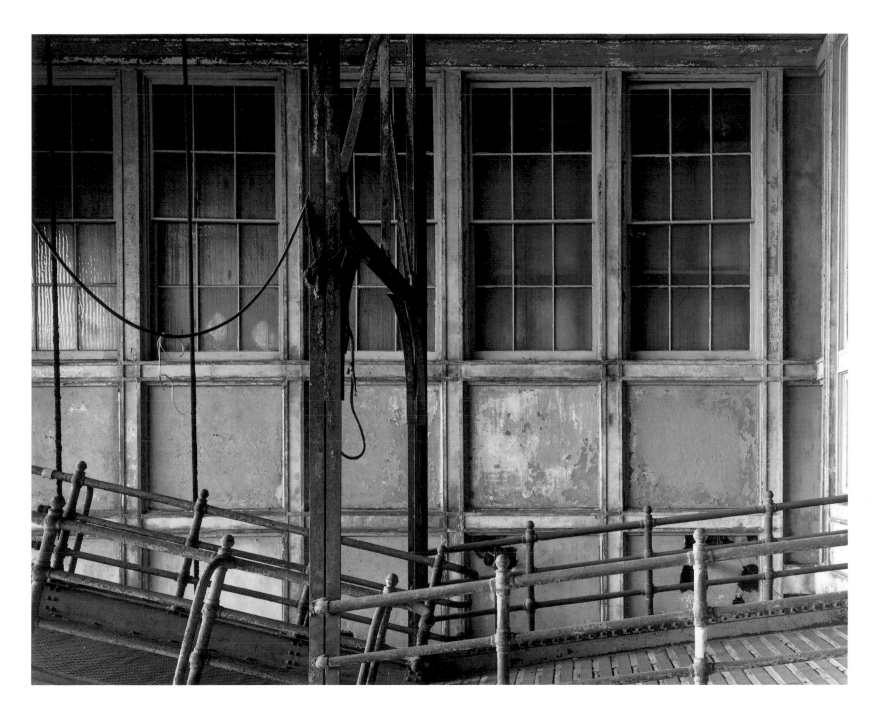

PLATE 28 Battery Maritime Building, Manhattan, 1991

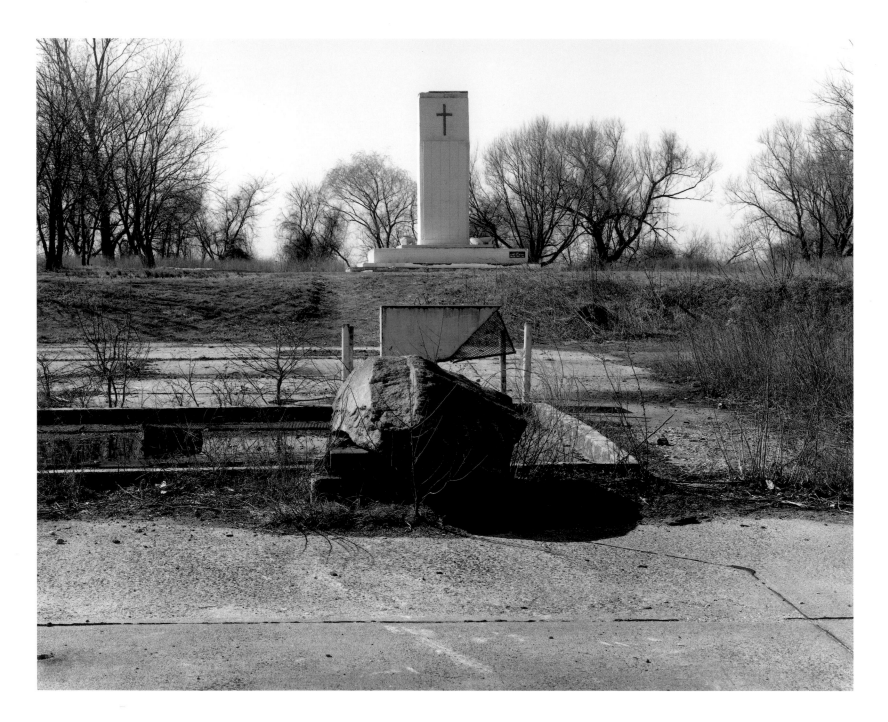

PLATE 29 Nike Missile Silo, Hart Island, Bronx, 1997

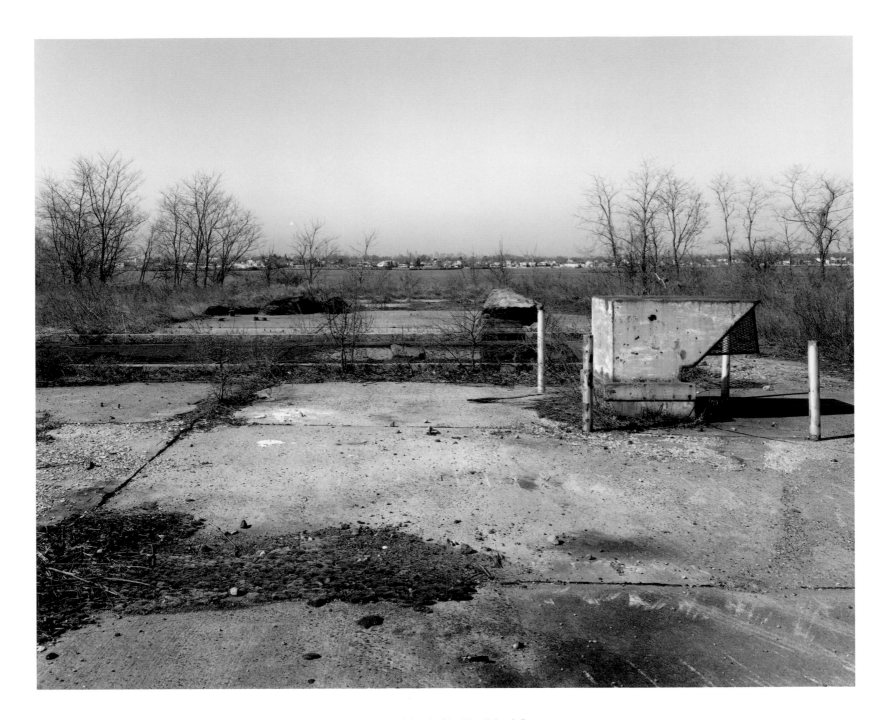

PLATE 30 Nike Missile Silo, Hart Island, Bronx, 1997

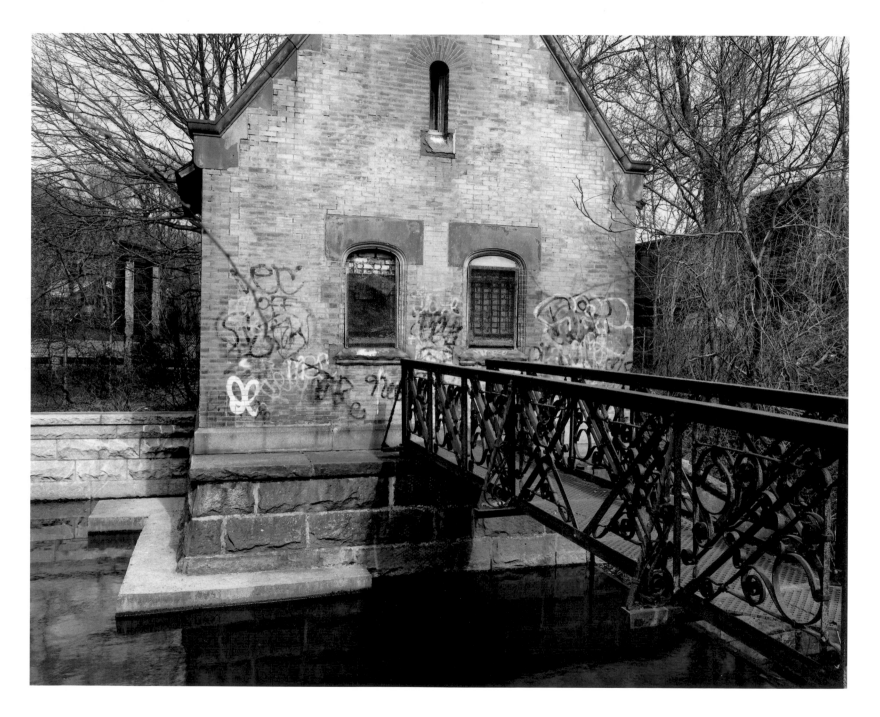

PLATE 31 Gatehouse, Brooklyn Water Supply, Wantagh, Long Island, 1997

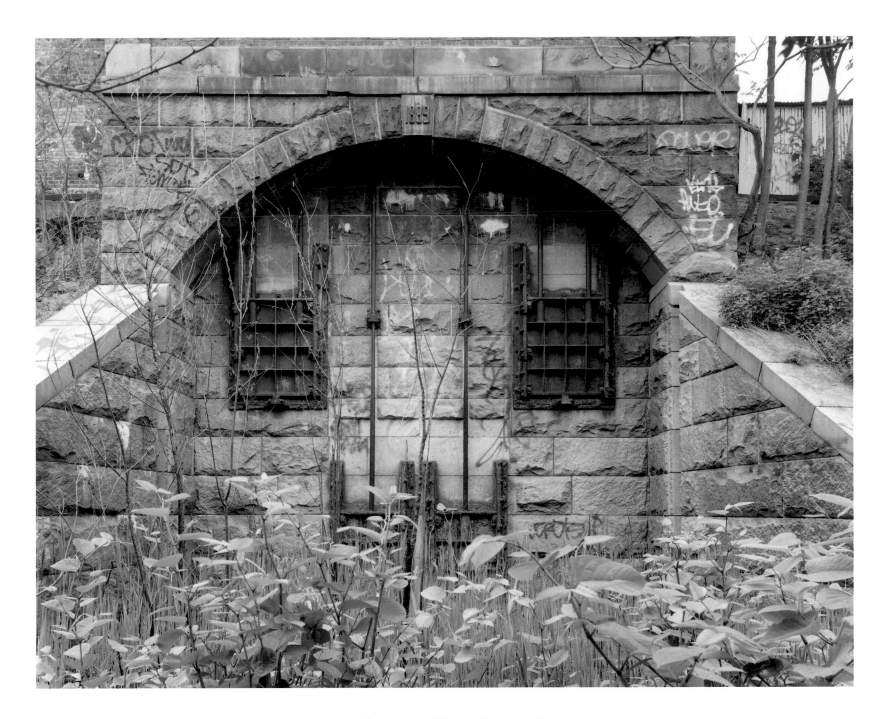

PLATE 32 Efflux chamber, Ridgewood Reservoir, Queens, 1997

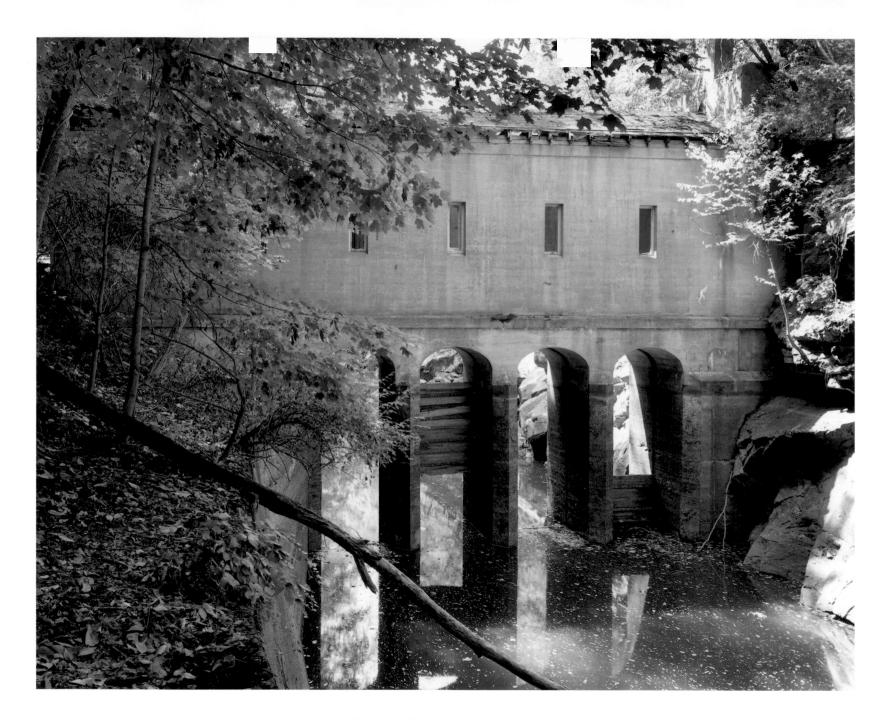

PLATE 33 Connecting Channel Gatehouse, Putnam County, 1995

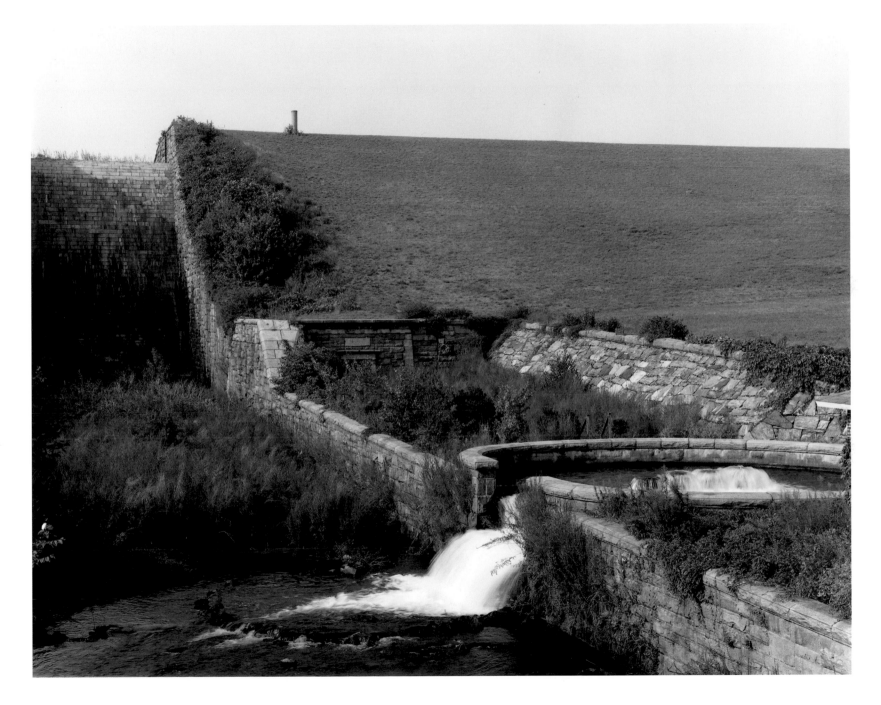

PLATE 34 Amawalk Dam, Westchester County, 1995

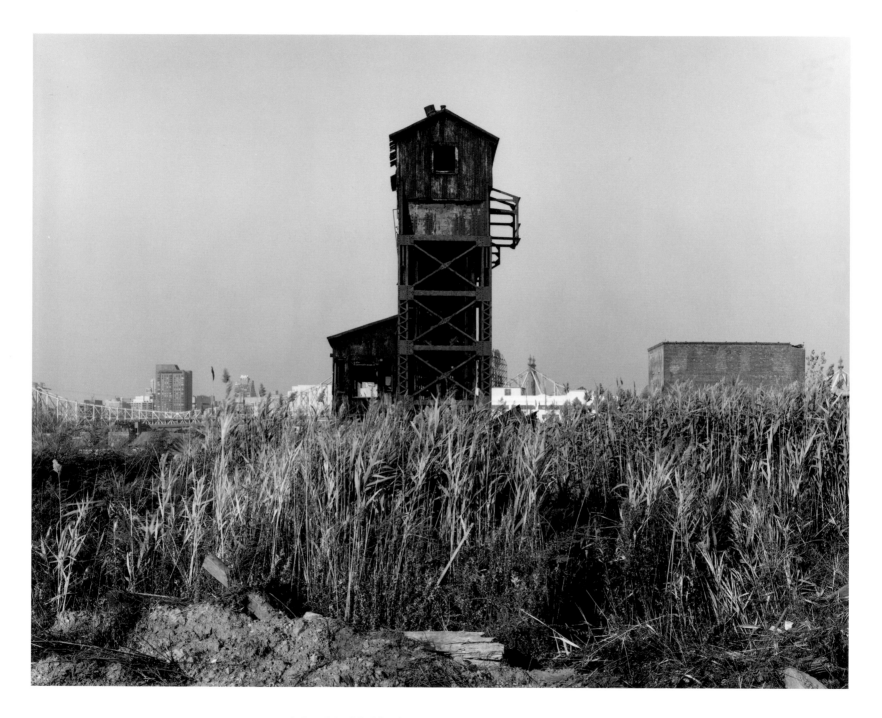

PLATE 35 Long Island Rail Road Barge Float Terminal, Hunter's Point, Queens, 1993

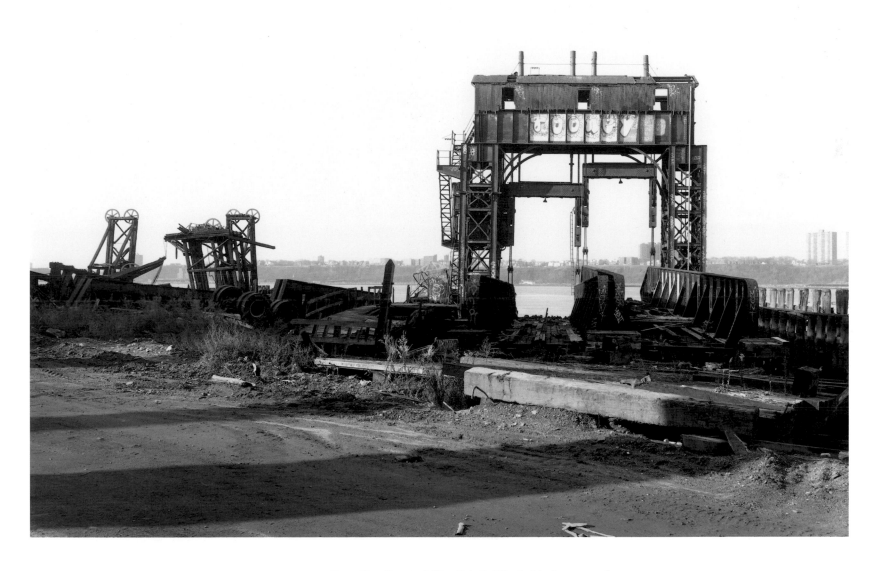

PLATE 36 Barge Float Terminal, West Side Rail Yards, Manhattan, 1993

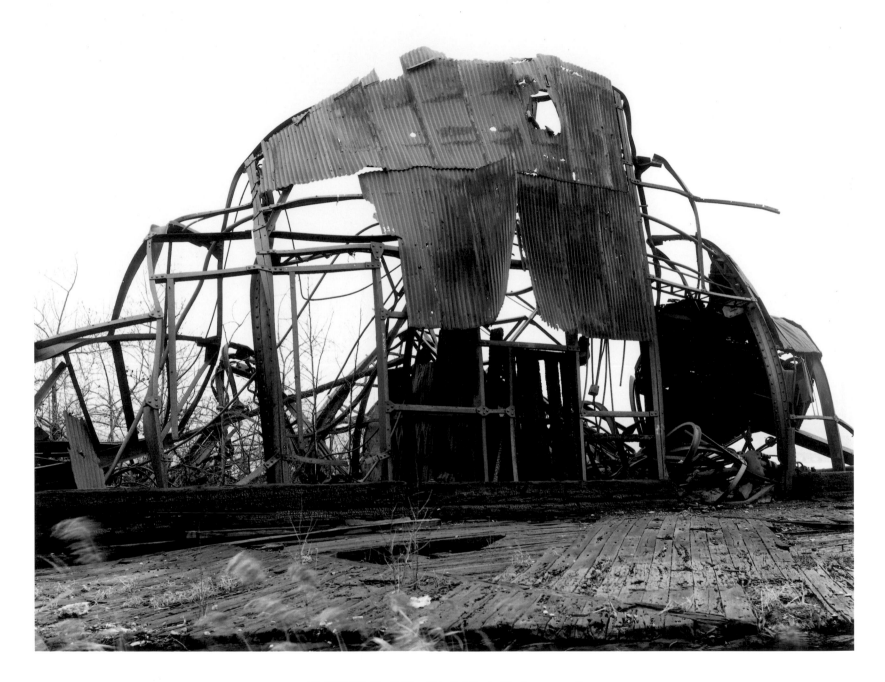

PLATE 37 Pier B, West Side Rail Yards, Manhattan, 1993

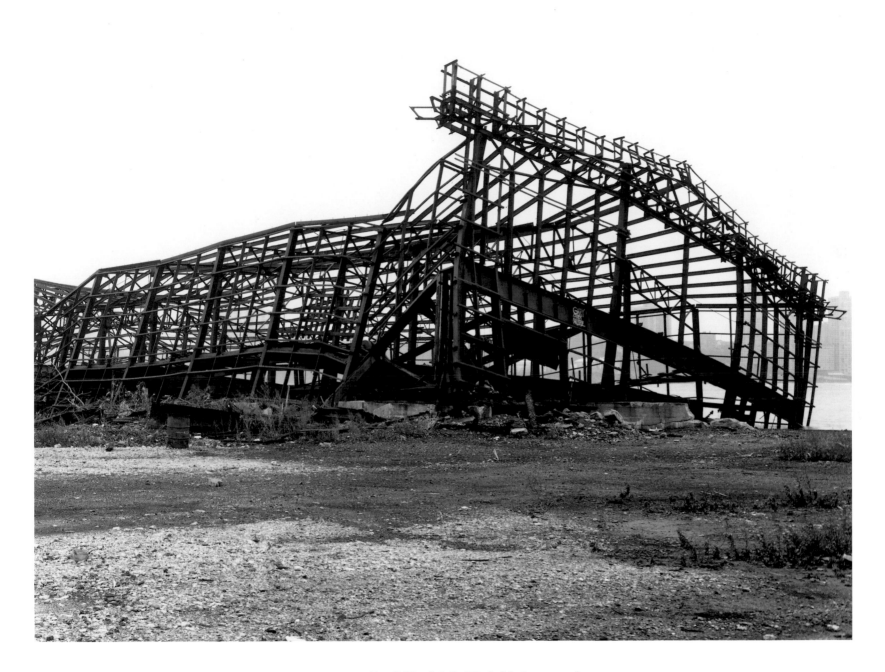

PLATE 38 Pier C, West Side Rail Yards, Manhattan, 1993

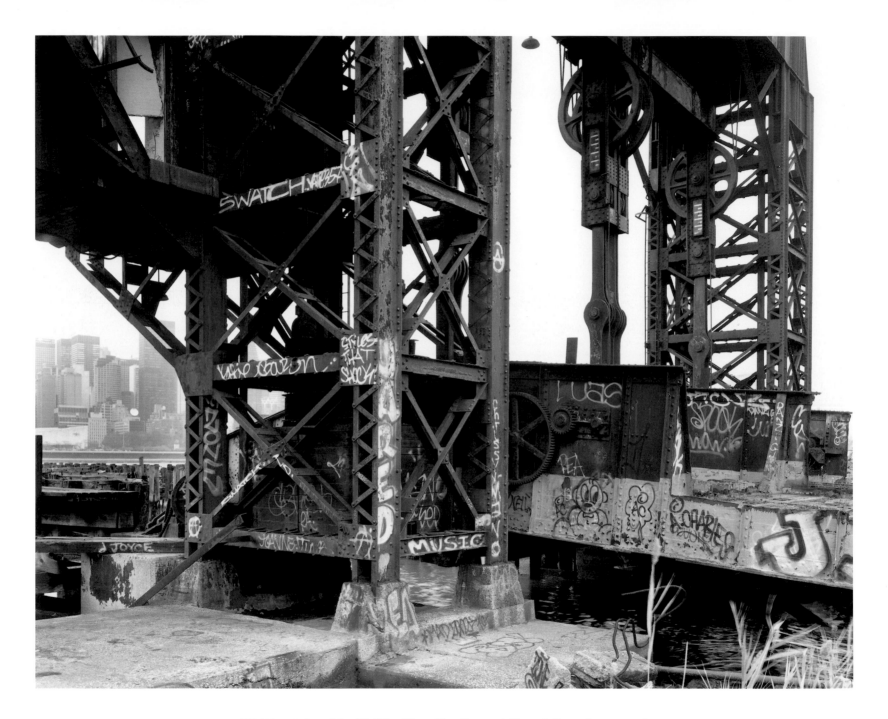

PLATE 39 Long Island Rail Road Barge Float Terminal, Hunter's Point, Queens, 1993

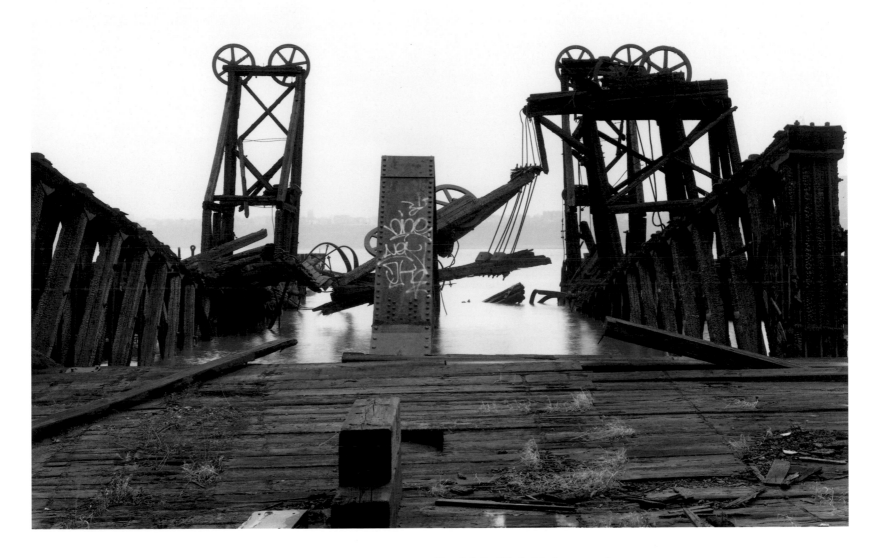

PLATE 40 Barge Float Terminal, West Side Rail Yards, Manhattan, 1993

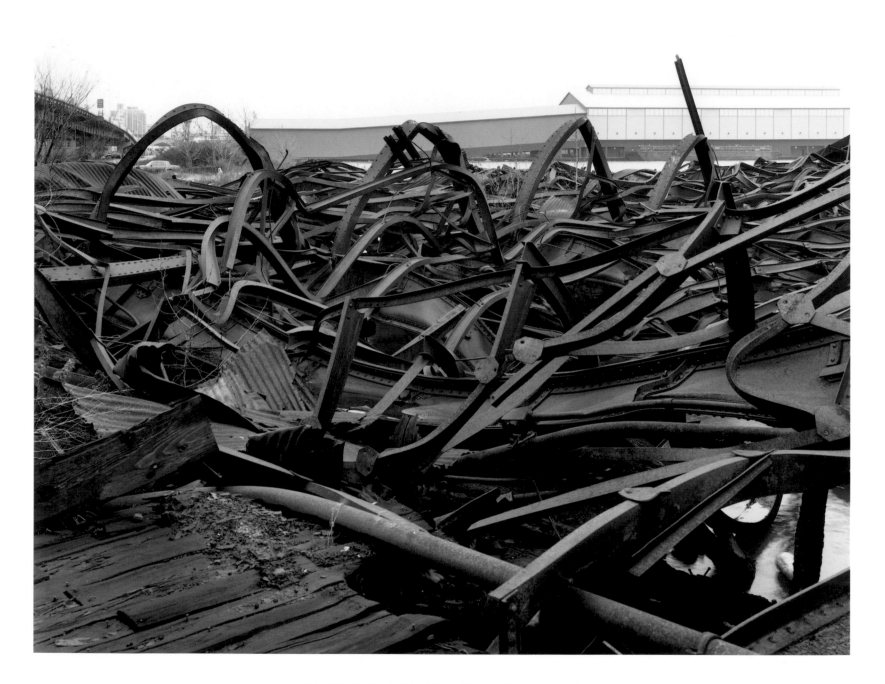

PLATE 41 Pier A, West Side Rail Yards, Manhattan, 1993

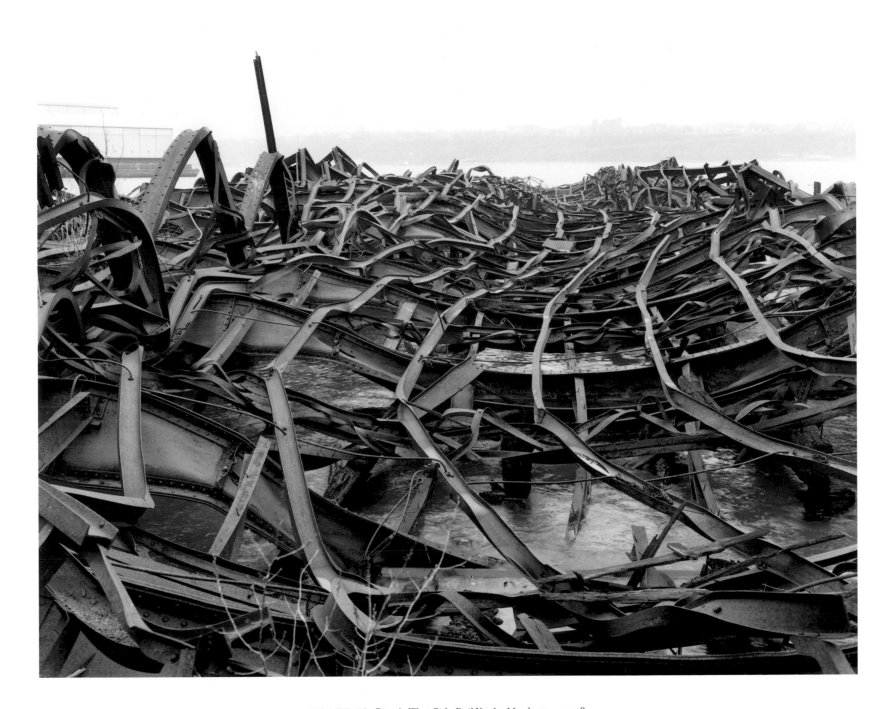

PLATE 42 Pier A, West Side Rail Yards, Manhattan, 1993

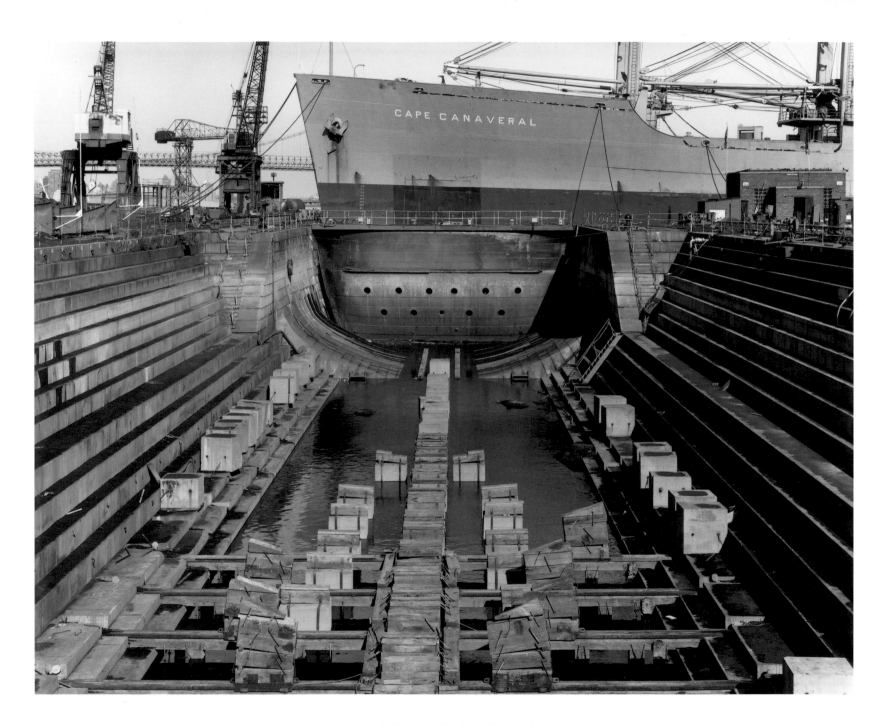

PLATE 43 Dry Dock, Brooklyn Navy Yard, 1991

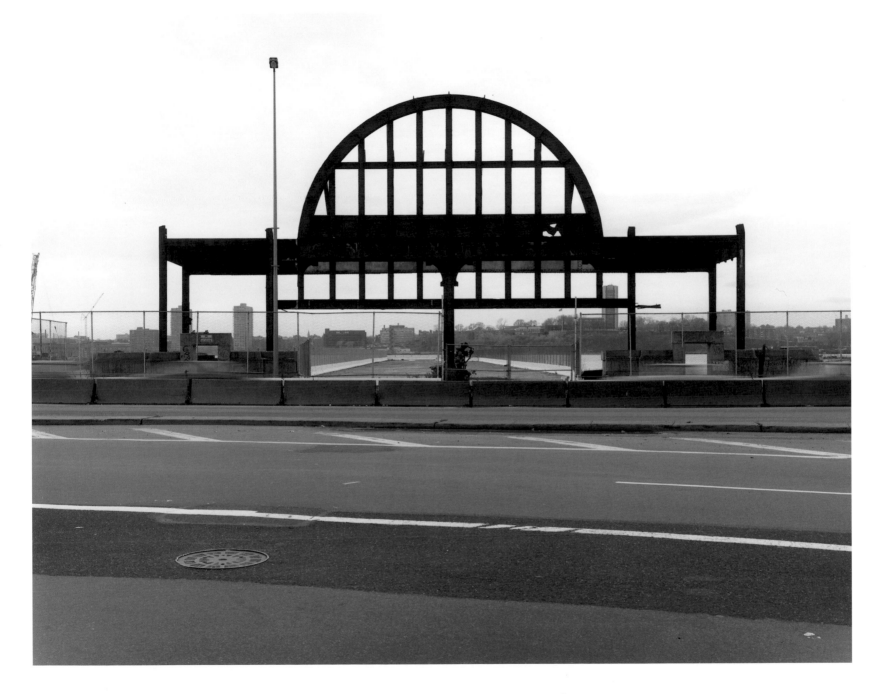

PLATE 44 Pier 54, Hudson River, Manhattan, 1993

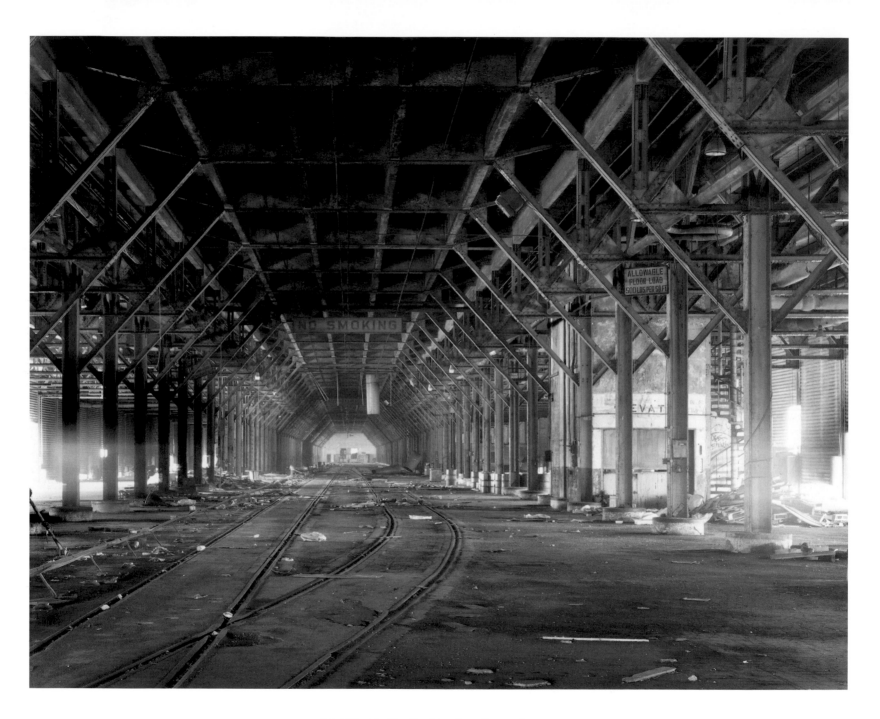

PLATE 45 Pier, Brooklyn Army Terminal, 1994

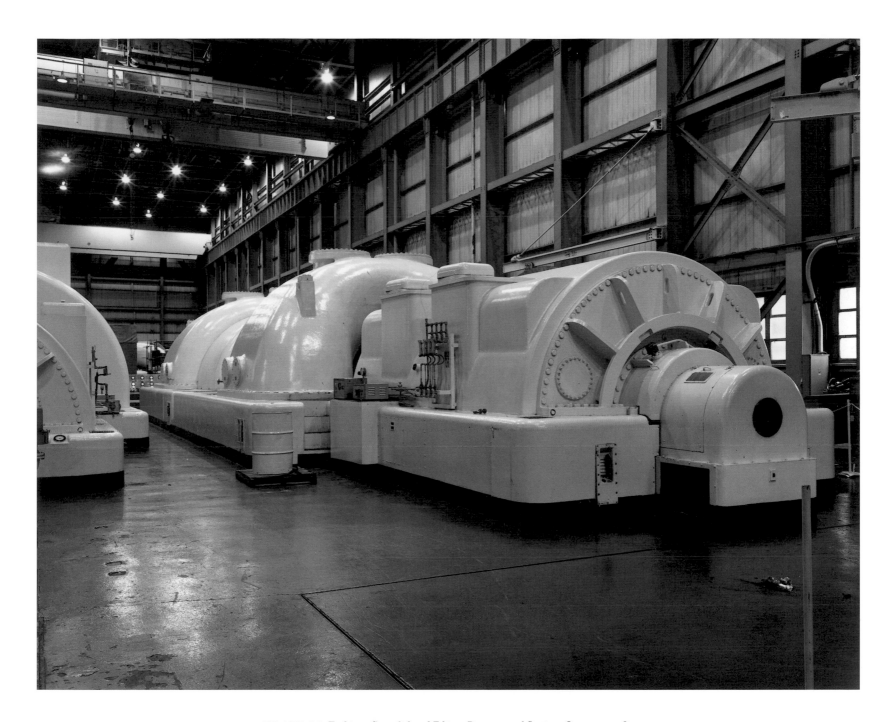

PLATE 46 Turbine, Consolidated Edison Ravenswood Station, Queens, 1993

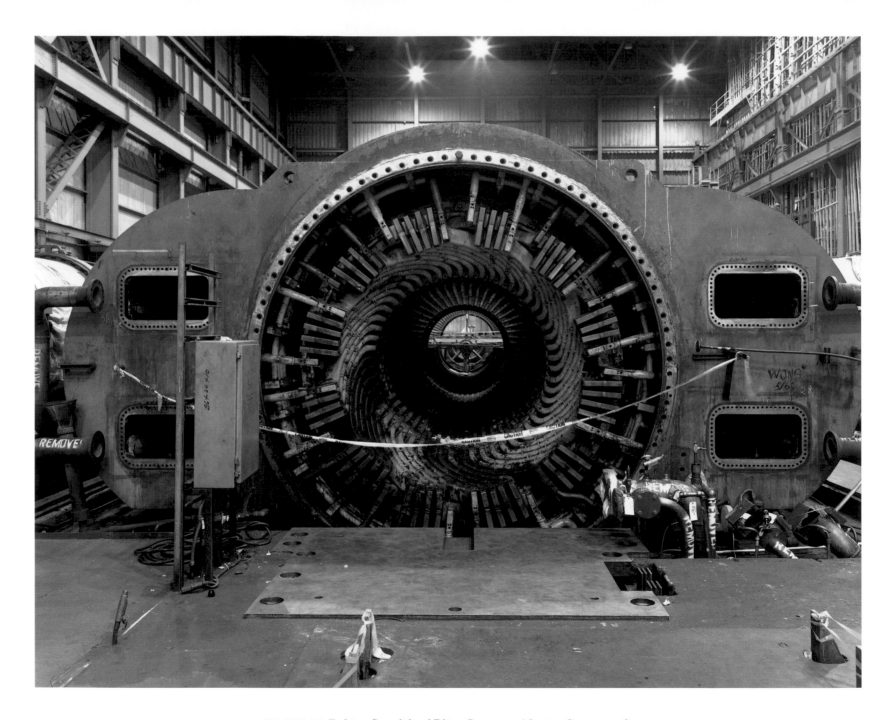

PLATE 47 Turbine, Consolidated Edison Ravenswood Station, Queens, 1993

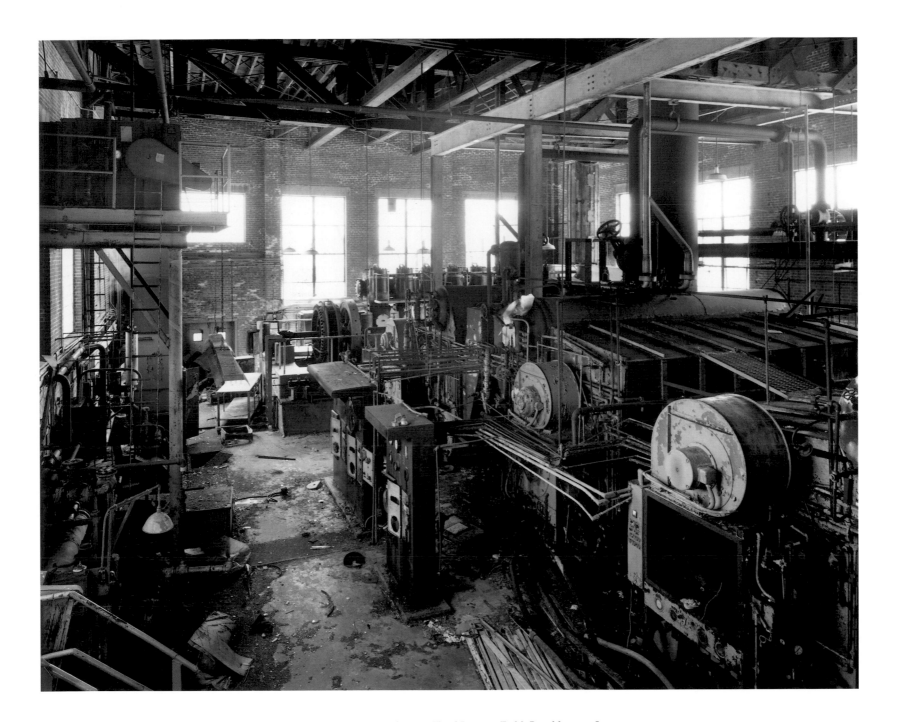

PLATE 48 Power Station, Floyd Bennett Field, Brooklyn, 1993

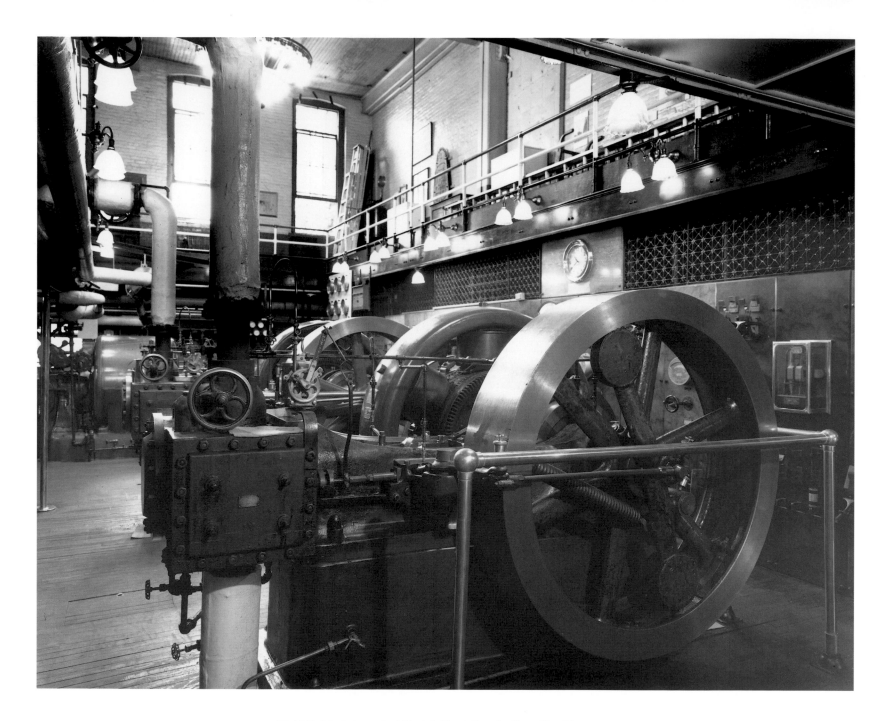

PLATE 49 Independent Electric Plant, Pratt Institute, Brooklyn, 1994

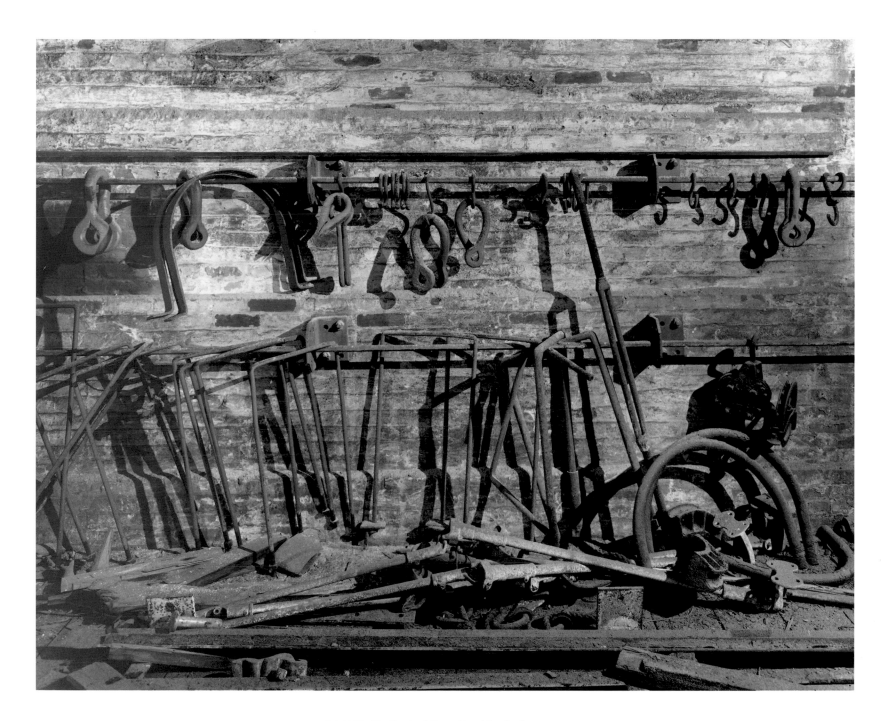

PLATE 50 Original Parts, Brooklyn Bridge, 1992

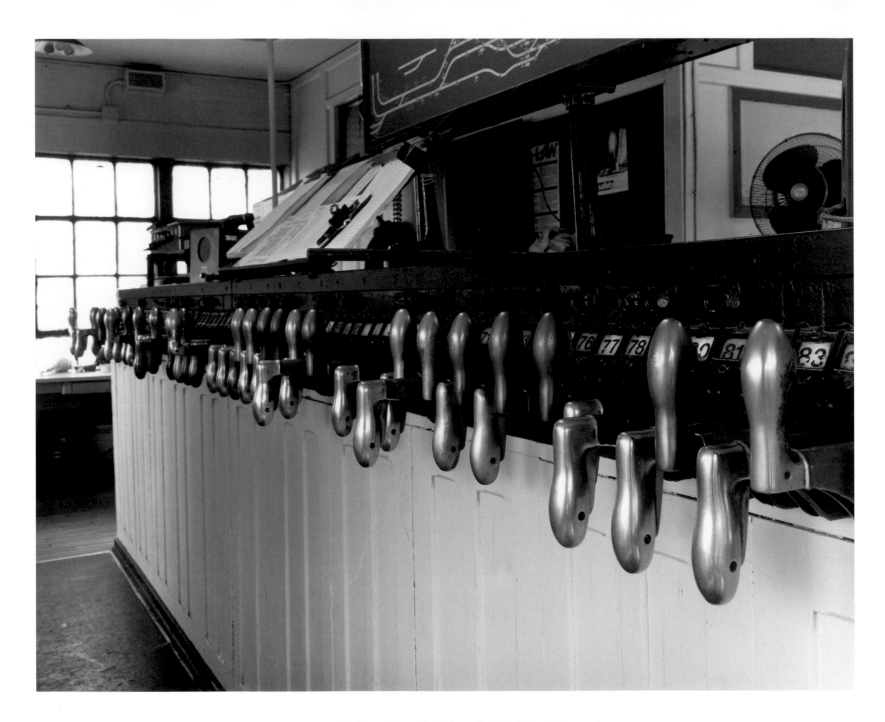

PLATE 51 Control Tower, 39th Street Rail Yards, Brooklyn, 1993

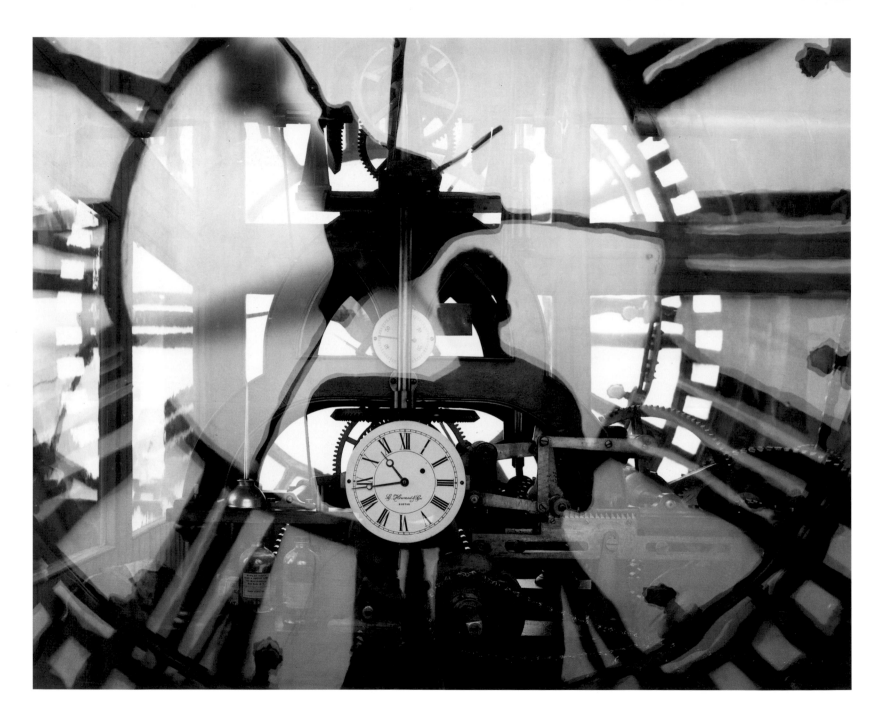

PLATE 52 Clock, 346 Broadway, Manhattan, 1996

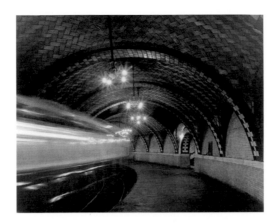

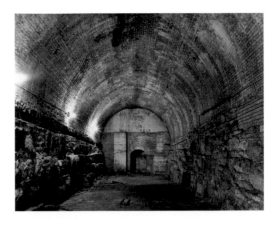

NOTES
ON THE PHOTOGRAPHS

FRONTISPIECE

City Hall Subway Station, 1993

The City Hall subway station was built in 1904 as part of the route that traveled north to Grand Central Terminal, west across 42d Street to Times Square, and then north again to Broadway at 145th Street. Designed by the firm of Heins and LaFarge, the station included Guastavino tile ceilings, bronze chandeliers, and glass mosaic skylights, all of which are still largely intact. The station is located just south of the Brooklyn Bridge station and is too short to be used by today's subway trains.

PLATE 1

Wine Cellar, Brooklyn Bridge, Manhattan, 1992

When the Brooklyn Bridge was completed in 1883 its granite towers were the tallest buildings in the world. Designed by John A. Roebling, the bridge was constructed by his son, Washington, after the senior Roebling's death. Washington became all but in-capacitated because of stress and an encounter with the "bends" resulting from too rapid depressurization after spending time in the underwater caissons used to construct the towers. His wife, Emily, became his eyes and ears and oversaw the completion of the structure.

The opening of the Brooklyn Bridge dramatically changed Brooklyn. Its population expanded rapidly before merging with New York in 1898. For many years the vault pictured here, located under the Manhattan approach to the bridge, was rented to a wine merchant for champagne storage because the temperature changed so little during the year. Other vaults similar to this one contain rusting fallout shelter helmets and casting patterns for the specialized parts of many of the city's old bridges.

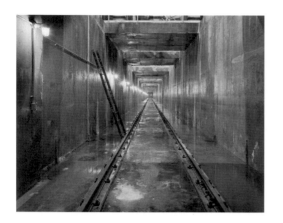

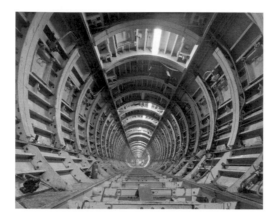

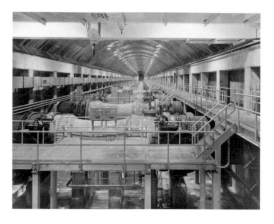

PLATE 2

Maintenance Tunnel, Valve Chamber, Shaft 2B,
City Tunnel No. 3, Bronx, 1992

The valve chamber pictured here, part of the city's
third water tunnel, is located 250 feet beneath Van
Cortlandt Park. The new tunnel, which distributes
water throughout the city, was designed to allow the
city's other two tunnels, built in 1917 and 1936, to be
shut down for inspection and repair. This valve
chamber, the largest in the system, allows parts of
the new tunnel to be shut down for maintenance. The
tunnel has been under construction since the late
1960s and may not be completed until 2020. Con-
ceived during the Cold War, it is designed to withstand
a nuclear blast.

 This photograph shows the maintenance track below
the valves (plate 6). If a valve needs to be taken apart
or replaced, it can be lowered onto this track and, if
necessary, moved to the far end of the chamber and
lifted to the surface.

PLATE 3

Construction Site, Shaft 19B, City Tunnel No. 3,
Queens, 1997

This site, 650 feet below the surface, is the meeting
point of the Brooklyn and Queens tunnels. After the
rock is removed (plate 5), steel forms are inserted and
concrete poured around them. Bubbles are removed
from the concrete by using air pressure to vibrate the
forms. After twenty-four hours the forms are removed,
leaving a smooth round tunnel sixteen or twenty feet
in diameter.

PLATE 4

Valve Chamber, Shaft 2B, City Tunnel No. 3, Bronx,
1992

I first visited this site in the early 1980s, when the
huge spaces had been cut out of the rock but little
concrete had been placed. That sight, which I have
never forgotten, helped lead me to this photographic
project. When I went to photograph it in 1992,
accompanied by my brother and a Department of
Environmental Protection guide, I entered through an
unmarked steel door in the side of a hill and then
descended in a small elevator. When the elevator
opened we were in the chamber, which because of its
great length feels more like a tunnel. The valves here
can be used to shut down individual parts of the
tunnel. Plate 6 provides a closer view of one of the
valves.

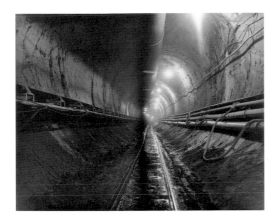

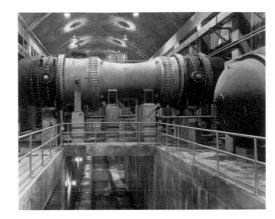

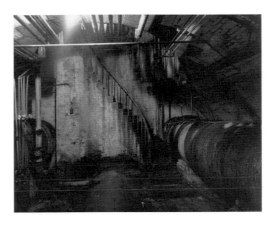

PLATE 5

Construction Site, Shaft 19B, City Tunnel No. 3, Queens, 1997

Until recently explosives were used to create these tunnels. Muck was removed after each blast, and then there was more blasting, followed by more muck removal. It was a slow process that required hundreds of "sandhogs," or tunnel workers. Now a tunnel-boring machine chews out the rock, and the rubble is removed by conveyor belt. Fewer workers are required now (three shifts of fifty workers each day on the Queens tunnel). The boring machine was approximately one mile ahead of where this photograph was taken. Although the machine has changed the basic way tunnels are dug, the construction site is still a very dangerous place.

PLATE 6

Valve Chamber, Shaft 2B, City Tunnel No. 3, Bronx, 1992

This is a closer view of one of the 96-inch valves in City Tunnel No. 3. The valve can be taken apart by removing the bolts on either side. The large round piece at the right is a cap that can be placed on the valve when it is down for repairs. At the bottom of the picture is the maintenance track shown in plate 2.

PLATE 7

Reservoir Gatehouse, Central Park, 1996

The Central Park Reservoir, completed in 1862, is the second reservoir to be located in the park. It was built to supplement the first Central Park Reservoir, constructed as part of the Croton Water System and completed in 1842. The new reservoir was authorized in 1851, but four years passed before the construction could begin since property owners wanted exorbitant fees for their land. Arbitration proved so complicated that the state legislature passed an act to speed the negotiations. The reservoir has a surface area of 96 acres and holds 1 billion gallons of water. It is not being used at the present time, but it is maintained in case of emergency.

This space, like many others in the system, was very poorly lit; it was difficult to determine what I was looking at, let alone where to step. The previous day a worker had stepped into a pool of water four feet deep here because it was so still that he did not see it. The thousands of runners that circle the reservoir pass this building every day, most of them completely unaware of what is inside. They may have seen the movie *Marathon Man*, but the scene apparently filmed here was shot somewhere else in the system.

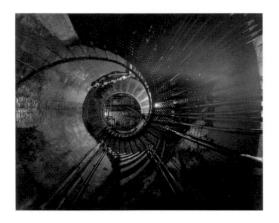

PLATE 8

Stairway, Reservoir Gatehouse, Central Park, 1996

The spiral stairway pictured here is used to reach the bottom of the gatehouse shown in plate 7. I was accompanied by a security guard who had never been downstairs. With one flashlight we managed to find our way around. We even discovered another entrance to the space from one of the Central Park transverse roads.

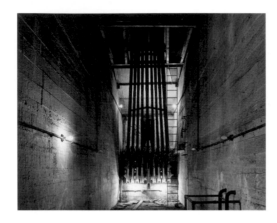

PLATE 9

Manhattan Anchorage, Manhattan Bridge, 1992

The Manhattan Bridge was opened in 1909 after years of struggle over its design. The engineer Gustav Lindenthal, briefly commissioner of bridges for New York City, threw out the original design, which called for a cable suspension bridge, and replaced it with an eyebar suspension structure. There was much controversy about the design, and when a new mayor was elected, he replaced Lindenthal. The bridge was then built largely as originally designed, with cables rather than bars; only the towers remained from Lindenthal's design.

 Lindenthal wrote about a similar steel bridge that "this colossal structure, if protected against corrosion, its only deadly enemy, will stand hundreds of years in unimpaired strength." The Manhattan Bridge, after decades of neglect and much corrosion, is now undergoing extensive reconstruction. This anchorage has been completely rebuilt with new concrete and cables.

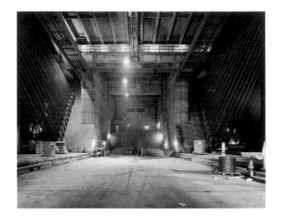

PLATE 10

Staten Island Anchorage, Verrazano-Narrows Bridge, 1992

The longest suspension bridge in the United States, the Verrazano-Narrows Bridge, connecting the boroughs of Brooklyn and Staten Island, was opened in 1964. It was the last bridge designed by Othmar Ammann, one of New York's most important engineers and the designer of many other New York spans, including the George Washington, Bayonne, Bronx-Whitestone, and Triborough Bridges. The bridge is 7,200 feet long with a central suspension span of 4,260 feet and towers 693 feet high. Eight thousand Brooklynites were uprooted from their homes to make room for the approach to the bridge, and a fort dating to Revolutionary War times was demolished to make room for the Brooklyn tower. Like the Brooklyn Bridge before it, the bridge led to major population growth, this time in Staten Island, since it made access to the rest of the city possible by other means than the ferry.

 The anchorage on the Staten Island side is located within Fort Wadsworth, and you have to pass through military checkpoints to get to it. It looks and feels almost like the inside of a giant piano, since the cables are strung on both sides and the whole room vibrates from the traffic overhead.

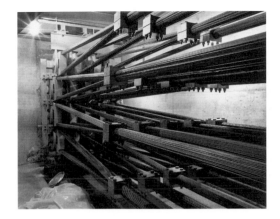

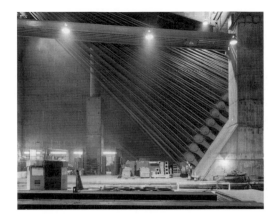

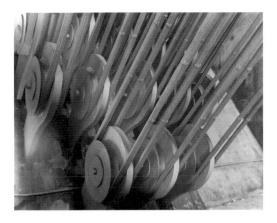

PLATE 11

Manhattan Anchorage, Brooklyn Bridge, 1992

This photograph shows the top of the anchorage, just below the roadway, where the cables attach to a series of anchor bars. These eyebars arc down to street level, 90 feet below, where they are attached to huge iron anchor plates. During construction the anchor plates were placed first, followed by the first eyebars. As the tower grew, eyebars were added, gradually curving toward the top to meet the cables. The nineteen strands shown here form one cable measuring 15.75 inches in diameter. Each of the four bridge cables is 3,578.5 feet long.

PLATE 12

Staten Island Anchorage, Verrazano-Narrows Bridge, 1992

This view shows the cables as they attach to the eyebars, which are sunk into the concrete anchorage, which in turn extends 76 feet below the surface.

PLATE 13

Staten Island Anchorage, Verrazano-Narrows Bridge, 1992

This close view shows where eyebars enter the concrete. One hundred forty-three thousand miles of wire were used for the cables, all held down by these masses of concrete. Each of the sixty-one eyebars anchors one set of 428 wires.

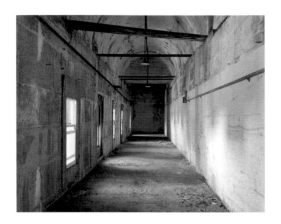

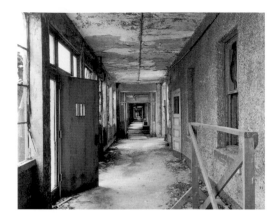

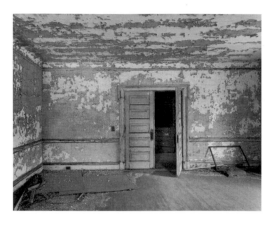

PLATE 14

Manhattan Gallery, Manhattan Bridge, 1992

This gallery, no longer in use and perhaps constructed only for its architectural effect, is now home to quite a few pigeons, who resented my presence.

PLATE 15

Hospital Hallway, Ellis Island, 1992

The hospital is in an area called Island Number 3, at the southern end of Ellis Island, which is really only one island. Designed by James Knox Taylor, the buildings were completed in 1909. However, they were not opened until 1911 because of a lack of equipment. By the mid 1920s the hospital was being used to confine seamen whose ships had docked in New York.

Prospective immigrants with contagious diseases such as measles, scarlet fever, and diphtheria were sent here for further diagnosis and treatment. At one end of this hallway is the morgue (plate 17); at the other end is a house for hospital staff (plate 16). Wards and semidetached structures opened off either side of this corridor. The building is now derelict, and its future is in doubt.

PLATE 16

Hospital Staff House, Ellis Island, 1992

Staff members who lived at the hospital were housed here, at the end of the hallway shown in plate 15.

After I finished making photographs here, I found it difficult to leave. Inside, the ruined spaces reminded me of the southern plantation houses Walker Evans photographed in the 1930s. Outside, I was alone, the bay in front of me and the empty buildings behind me. My grandparents entered the United States through this place, and for me these crumbling structures are much more powerful and evocative than the cleaned-up theme park of the restored Great Hall next door.

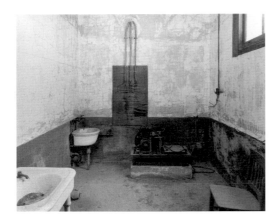

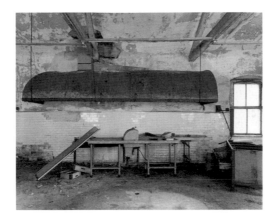

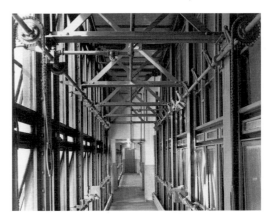

PLATE 17

Morgue Preparation Room, Ellis Island Hospital, 1992

The morgue preparation room is located behind the morgue and autopsy room, at the end of the hospital hallway (plate 15). The compressor maintained the temperature in the refrigerated body cooler. Later this facility was used to house laboratory animals.

This room is quite eerie, but it should be noted that several advances in public health were made at Ellis Island. The Public Health Service was founded here, and a cure for pinkeye, which commonly led to blindness, was discovered here.

PLATE 18

Kitchen, Kitchen and Laundry Building, Ellis Island, 1992

The kitchen was where meals for prospective immigrants and government workers were prepared. It was partially staffed by detained aliens. It probably also served the American sailors who were permitted to use the hospital, as well as the German officers and sailors interned here during World War II.

PLATE 19

Catwalk, Grand Central Terminal, 1993

Walkways such as this, on several floors, are located in a narrow space between the huge arched windows on the west side of the terminal. One side looks down on the great hall of the terminal, while the other side opens onto Vanderbilt Avenue. Here one feels suspended in air, being inside and outside at the same time. I also felt exposed, like an ant moving through one of those glass-sided ant farms.

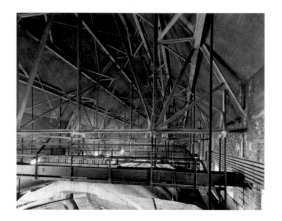

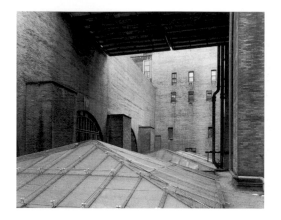

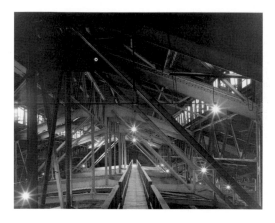

PLATE 20

Attic, Cathedral Church of St. John the Divine,
Manhattan, 1993

St. John the Divine is the largest cathedral, and the
third-largest church, in the world, and its design has
been anything but consistent. It was originally
designed by Heins and LaFarge in the Romanesque
style, and construction was begun in 1892. Only the
apse was built before the style was felt to be so out of
date that Ralph Adams Cram was asked to redesign the
building in the French Gothic style. Construction of
the nave and transepts in the Gothic style were com-
pleted, but the crossing, where the two styles meet,
has never been resolved, despite efforts by a number of
well-known architects to solve the problem. Construc-
tion of the church continued for almost 50 years before
stopping abruptly on 7 December 1941. It resumed
again in 1982 and will continue far into the future.

The cathedral's design is historically correct, but
modern building methods were employed and the roof
above the great stone vaults is carried by a fireproof
steel structure. This site posed the same photographic
problem that I faced at many other sites shown in this
book: very little light, and always from only a few point
sources.

PLATE 21

Roof, Grand Central Terminal, 1993

Grand Central Terminal, built between 1903 and 1913,
was designed by the firms of Warren & Wetmore and
Reed & Stem and incorporated a number of innova-
tions. Long ramps replaced most stairways in connect-
ing two track levels, with the street and with each
other. Because of the advent of electrically powered
trains, all of the tracks were below grade. This
permitted new offices and hotels to be constructed
above them and was the first use of urban air rights.

The arched windows on the left open onto the south
side of the Main Concourse of the terminal. The
skylights cover the recently restored main waiting
area, which is now used for exhibitions and seasonal
commercial ventures.

PLATE 22

Attic, Grand Central Terminal, 1993

This attic space, above the Main Concourse, is similar
to the attic of the Cathedral Church of St. John the
Divine and indicates how the roof is constructed over
the rounded ceiling of the terminal. The newly
restored rendering of the constellations of the night
sky are on the inside of the ceiling below, and the light
bulbs that represent the stars are changed from this
space.

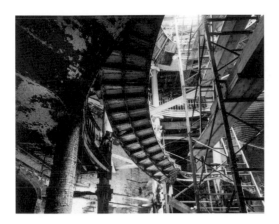

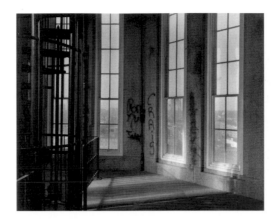

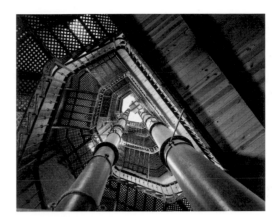

PLATE 23

Lunatic Asylum, Roosevelt Island, 1993

The Octagon Building, as it is now called, was the central connecting structure for the L-shaped city Lunatic Asylum, a large hospital that housed seventeen hundred patients, twice as many as it was designed to hold. Designed by Alexander Jackson Davis, the asylum was completed in 1839, when the island was called Blackwell's, after the family from whom the city bought it. The asylum was visited in 1842 by Charles Dickens, who liked the architecture but not the "long, listless, madhouse air." In 1887 the investigative journalist Nellie Bly had herself committed to the institution so that she might get a better idea of what life was like there. She exposed its conditions as a "human rattrap" and wrote about patients being chained to their beds. Her articles resulted in new expenditures and changes in procedure to upgrade conditions. The building was abandoned in 1955. The Roosevelt Island Operating Corporation has put a new roof on the building and plans to stabilize it as a ruin.

PLATE 24

Interior, High Bridge Tower, Manhattan, 1995

High Bridge Tower was completed in 1872. The tower, along with a small reservoir and pumping station, was built to supply higher elevations of northern Manhattan with water from the Croton system. However, other higher elevations of Manhattan were also served, and a water main from the tower was built as far south as 42d Street. Water was pumped to the tower from the Croton aqueduct, which crossed the Harlem River by way of the High Bridge. There was also a reservoir, which held nearly 11 million gallons of water. The reservoir has been replaced by a swimming pool.

This remnant of the Croton system provides beautiful views of Manhattan, the Bronx, and the George Washington Bridge. Looking out over the buildings, it is hard to imagine that when it was built the area was mostly farmland.

PLATE 25

Interior, High Bridge Tower, Manhattan, 1995

This is the view looking upward in the 170-foot tower. The space in the middle is partially filled by the pipe that brought water to the tank in the upper part of the tower. Unfortunately, the tank, which held 47,000 gallons of water, was cut up and burned by vandals and has been removed. The tower structure was restored in the 1980s.

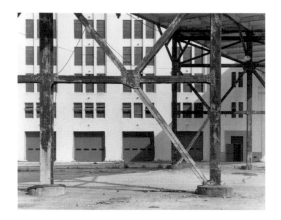

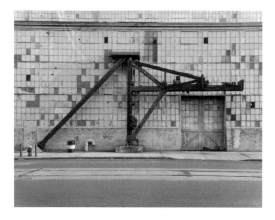

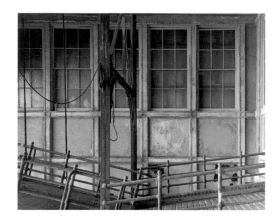

PLATE 26

Brooklyn Army Terminal, 1994

The Brooklyn Army Terminal was heavily used to ship personnel and materials to Europe during World War II. The building, seen here in the background, was connected to the piers (plate 45) by large overhead passageways supported by the steel structure pictured here.

PLATE 27

Crane, Sunset Park, Brooklyn, 1990

This crane, now gone, was used to swing freight into the building from trains that traveled down the track laid in the middle of the street. On one of the days that I was photographing here a train with a load of new subway cars interrupted my work as it rolled down the street on the way to testing at the Brooklyn Army Terminal Pier (plate 51).

PLATE 28

Battery Maritime Building, Manhattan, 1991

The Battery Maritime Building, built in 1906 and designed by the firm of Walker and Gillette, is the last of the old ferry terminals in New York City. Originally a terminal for ferries to Brooklyn, Staten Island, and Governors and Ellis Islands, in recent times it served the Coast Guard staff and families that lived on Governors Island.

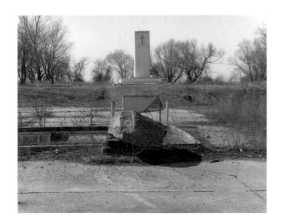

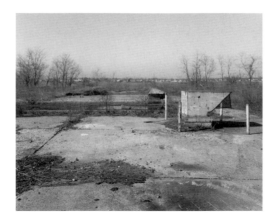

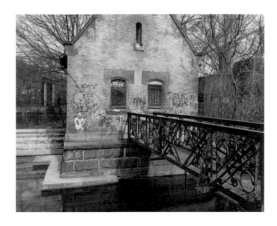

PLATE 29

Nike Missile Silo, Hart Island, Bronx, 1997

Hart Island is a place most people associate with death, the place where the city buries unclaimed bodies. This practice, begun in 1869, is now carried on by inmates from Riker's Island Correctional Facility. More than eight hundred thousand bodies have been buried on Hart Island. The monument in this photograph was built by the inmates in memory of those they buried.

For several years, the cemetery shared the island with the country's first Nike missile base, which is partially visible in the foreground of the photograph. The missiles had a range of thirty miles, and the base was intended to protect New York City from an attack. The missile base was active from 1955 to 1961, when longer-range missiles made it obsolete.

PLATE 30

Nike Missile Silo, Hart Island, Bronx, 1997

The cover of the missile silo is visible here, overgrown with weeds. The cliff next to the silo is eroding, as soil is used for the nearby burials. It may only be a matter of time before the insides of the silo are exposed. I was not permitted to enter the silo, but I could see that water was standing several feet deep in the bottom.

PLATE 31

Gatehouse, Brooklyn Water Supply, Wantagh, Long Island, 1997

A few structures from the water system built by the City of Brooklyn remain. The earliest were put into operation in 1857, and others were built during the remainder of the nineteenth century. The building pictured here was completed in 1896; it is now all but hidden, fenced in and overgrown, next to a highway exit. There is little to indicate its former function and how important it was to the health and well-being of the Brooklyn and Queens residents it served.

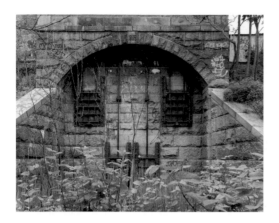

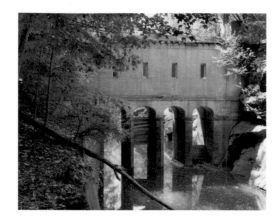

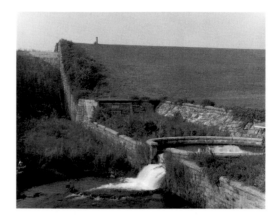

PLATE 32

Efflux chamber, Ridgewood Reservoir, Queens, 1997

The Ridgewood Reservoir was the main reservoir for
the Brooklyn water system. Originally constructed in
1857, it was enlarged in 1890, the year this chamber
was built. From here water was supplied to much of
Brooklyn and Queens. The system was shut down
around 1966. Plant and animal life has taken the land
back, and it is now a very unusual place to visit; it is
one of the few truly wild places in the city, although its
future is in doubt. On my visit I saw herons, pheasants,
warblers, and some very large rabbits.

PLATE 33

Connecting Channel Gatehouse, Putnam County, 1995

This gatehouse, now out of commission and concealed
from view, was pointed out to me by a Department of
Environmental Protection employee. It looks as
though it might have been moved here from Renais-
sance Italy, and I have gone back to see it several times
because it is such an interesting place. In use, it
controlled a channel between the East Branch Divert-
ing and Croton Falls Reservoirs so that their levels
could be equalized, permitting maximum storage
capacity. Wooden gates operated from within the
gatehouse controlled the water flow. The first time I
visited, the water was so still and covered with leaves
that it looked almost solid. When this photograph
was made the water level was much lower, exposing the
arches where the gates used to operate.

PLATE 34

Amawalk Dam, Westchester County, 1995

The Amawalk Dam and Reservoir were completed in
1897 by the New York City Department of Public
Works. The reservoir holds just over 7 billion gallons of
water. The dam is constructed of earth fill over a con-
crete core, except for the masonry spillway seen in the
photograph. The dam is now being partially recon-
structed in order to comply with federal safety
regulations.

I found this dam to be one of the more unusual in
the Croton system; many of the details that have been
removed from other dams still exist here. Unfortu-
nately, the only way to photograph the dam was to stand
on a very narrow shoulder of a busy road that curved
away from the dam. I tried not to look at the trucks
barreling toward me as I took my exposure readings
and hoped that there were no careless drivers out there
as I went under the dark cloth.

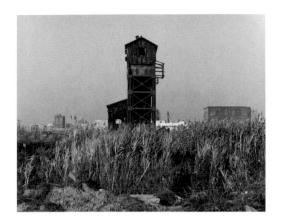

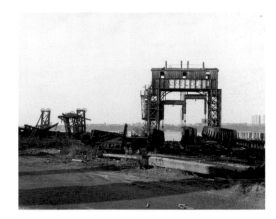

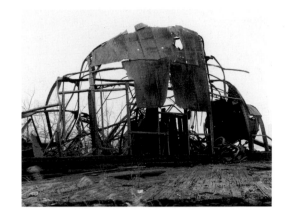

PLATE 35

Long Island Rail Road Barge Float Terminal,
Hunter's Point, Queens, 1993

Trains from Long Island could not travel to Manhattan
until the construction of Pennsylvania Station in 1910.
Before that time passengers took ferries to and from
Manhattan and boarded trains at the LIRR terminal
here. Barge floats carried loaded freight cars here as
well. From Manhattan they transported horse manure
from the streets of New York to the farms of Long
Island, and in return the farms supplied the city with
potatoes, cauliflower, asparagus, and milk.

PLATE 36

Barge Float Terminal, West Side Rail Yards,
Manhattan, 1993

The 60th Street rail yards were the most extensive in
Manhattan at the time of their construction by the New
York Central Rail Road between 1877 and 1882. The
yards stretched from West 60th Street north to West
72d Street, ending at the southern tip of what is now
Riverside Park. They spanned the distance between
11th Avenue and the Hudson River. At one time the
yards included sections to make up east- and west-
bound trains, eight piers for ships and barge ferries, a
grain elevator, stockyards, and an engine service
terminal.

In 1911 the city required that all railroad tracks
below 59th Street that were still at grade be removed,
so these rail yards survived longer than other similar
waterfront facilities in Manhattan. The yards are the
site of a huge office complex now under construction.

The piers are in different stages of decay. One
has melted nearly into the water, another has been
strangely skewed, and the barge float terminals, where
freight cars were rolled onto barges for transport
across the river, have been picked apart. The piers are
located directly below the West Side Highway, and can
be seen by all the people who pass overhead in their
cars if they only take the trouble to look over the edge.

PLATE 37

Pier B, West Side Rail Yards, Manhattan, 1993

Not much remains of this pier, which, like those
nearby, has been burned and corroded over time.

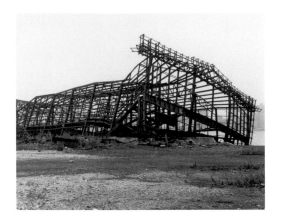

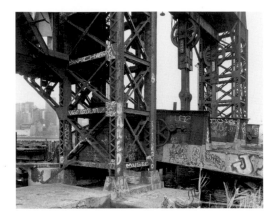

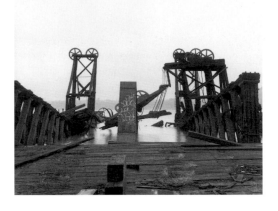

PLATE 38

Pier C, West Side Rail Yards, Manhattan, 1993

This pier seems to be listing into the water under its own weight, as the piles below it slowly collapse. As the water quality in the Hudson River has improved, woodborers have returned, eating away at the piles. It is possible that they have sped up this pier's movement into the water.

PLATE 39

Long Island Rail Road Barge Float Terminal, Hunter's Point, Queens, 1993

This is a closer view of the terminal shown in plate 35, which now has been partially restored as a feature of a new housing and park complex called Queens West.

PLATE 40

Barge Float Terminal, West Side Rail Yards, Manhattan, 1993

This is a closer view of part of the barge float terminal shown in plate 36.

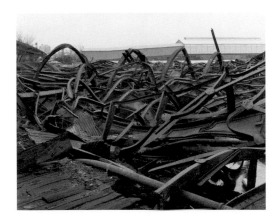 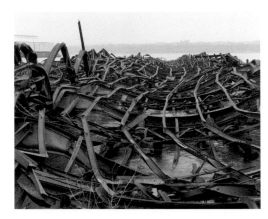 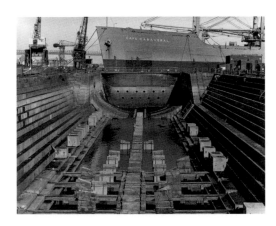

PLATE 41

Pier A, West Side Rail Yards, Manhattan, 1993

This pier was destroyed by fire. One of the Sanitation Department's marine transfer stations is visible in the distance.

PLATE 42

Pier A, West Side Rail Yards, Manhattan, 1993

This photograph shows another view of the pier in plate 41.

PLATE 43

Dry Dock, Brooklyn Navy Yard, 1991

The Federal government first purchased land for the Navy Yard in 1801. Construction of its dry dock, large enough to hold a ship three hundred feet long, was begun in 1841; steam pumps were used to empty the water. According to Rev. John Francis Richmond, writing in *New York and Its Institutions* in 1871, "It is a place of curiosity, and is visited by many thousands annually, but as it occupies nearly the heart of the City, the enterprising property owners would gladly see it removed. Congress has begun to debate the matter of its removal, and it will probably be accomplished before many more years elapse." The yard was the site of much shipbuilding during World War II, but its operation has since been turned over to the city and it is now used mostly for ship repairs and other unrelated small businesses.

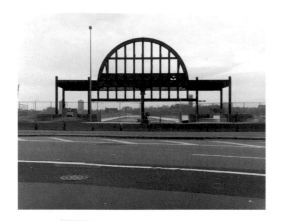

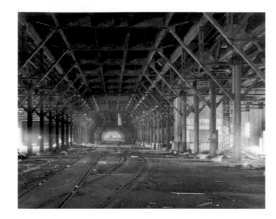

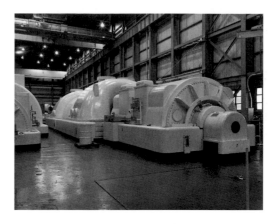

PLATE 44

Pier 54, Hudson River, Manhattan, 1993

Pier 54 was the southernmost of the Gansevoort piers. Opened in 1902, the piers were built on Manhattan's west side as part of an attempt to bring order to the chaos of the waterfront. The innovative design built into the island of Manhattan to create the length needed to accommodate the increasingly larger ships of the day. All that remains now of this former Cunard Line pier is the structural frame of the front door and windows.

PLATE 45

Pier, Brooklyn Army Terminal, 1994

Originally called the New York Port of Embarkation and Army Supply Base, the terminal was designed by Cass Gilbert, architect of the Woolworth Building, and built in 1918. The building was originally used for commercial shipping and to supply local and foreign units of the Army. When it was built it had more storage space than any other building in the world in addition to the space for the two train tracks running through it. The pier is connected to the terminal by a large overhead passageway (plate 26). In recent times the pier was used to test new subway cars. It is now scheduled for demolition, but all asbestos must be removed before it is torn down.

PLATE 46

Turbine, Consolidated Edison Ravenswood Station, Queens, 1993

Consolidated Edison operates the largest steam turbine alternator electrical generators in the world in its Ravenswood Station in Queens. Completed in 1965, Ravenswood was originally planned as a nuclear generating station, but public opposition prevented this from happening and the design was changed to allow the plant to run on coal. More recently, it was switched over to cleaner-burning fuel oil. The two smaller generators are rated at 390 megawatts, the largest ("Big Allis") at 1,000 megawatts.

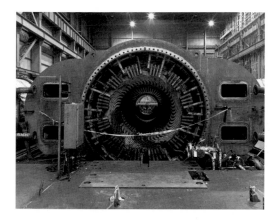

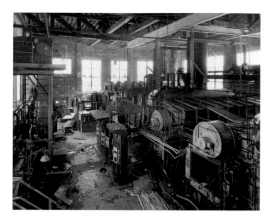

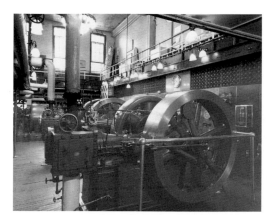

PLATE 47

Turbine, Consolidated Edison Ravenswood Station, Queens, 1993

The turbine pictured here was being repaired at the time of my visit, so I had an opportunity to see the massive copper windings in its interior.

PLATE 48

Power Station, Floyd Bennett Field, Brooklyn, 1993

Floyd Bennett Field, the city's first municipally owned commercial airport, was opened in 1931 in an area formerly known as Barren Island, home to a small community of working poor, along with a city incinerator and a glue factory. It was not successful, in part because the U.S. Postal Service would not switch from its local air mail terminal at Newark, which also handled the commercial passenger flights at the time. Mayor Fiorello LaGuardia was one of the field's biggest supporters and once insisted that his flight land at Floyd Bennett rather than Newark because his ticket said "New York."

Even the publicity this story received did not save the field from commercial failure, but it became an important place for many record-breaking flights. Amelia Earhart, Howard Hughes, Laura Ingalls, and Charles Lindbergh all flew from there. During World War II (1942) the Navy took over the field, and it became one of the country's busiest military airports. The airport was decommissioned in the early 1970s and is now part of Gateway National Recreation Area.

The power station, now derelict, furnished heat to the terminal buildings and electricity for the runway lights.

PLATE 49

Independent Electric Plant, Pratt Institute, Brooklyn, 1994

One of the last independent electrical generating plants in the city is operated by Pratt Institute, an art school in Brooklyn. The plant dates to 1888, but the present operation, with three direct-current generators driven by steam reciprocating engines, has been in daily use since 1900. For the past forty years it has been lovingly maintained by Conrad Milster, often with parts salvaged from other such plants that were shut down and scrapped.

While on the outside this building is an anonymous part of the campus, its interior is a living museum. The machines are placed so close together, and the motions of the piston rods, cranks, and valve gears are so fascinating, that I felt as though I were inside a mechanical organism.

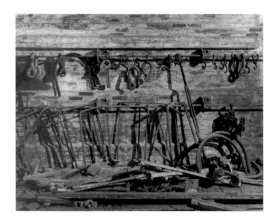

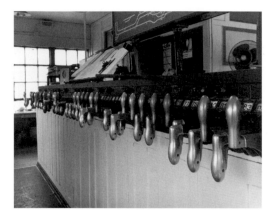

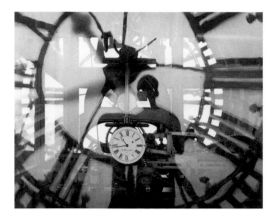

PLATE 50

Original Parts, Brooklyn Bridge, 1992

I found these parts and tools, possibly undisturbed since the bridge's completion in 1883, in one of the arches that support the Manhattan approach to the bridge. A nearby arch had a small mountain of fallout shelter helmets, untouched since being placed there during the Cold War.

PLATE 51

Control Tower, 39th Street Rail Yards, Brooklyn, 1993

The 39th Street Yard in Brooklyn is a major dispatching point where trains are made up and sent on their way. It is also the home base for some of the system's diesel locomotives, which are directed from the control room shown here. Diesels are used for all kinds of maintenance of the system and are particularly useful if electrical power to the third rail has been interrupted. One unit, which uses a converted jet engine, is used for snow removal.

 At one time all the switch towers, as these control stations are called, resembled this one, with metal switch control handles well polished by decades of use. Now most have been converted to electrical operation, with push buttons replacing manual control handles.

PLATE 52

Clock, 346 Broadway, Manhattan, 1996

This is the largest mechanical clock in New York City, located in a tower in a city-owned building in lower Manhattan. The building was completed in 1870 by Griffith Thomas as the home for the New York Life Insurance Company and was expanded and remodeled in the 1890s by McKim, Mead and White. It was subsequently bought by the city and now houses a variety of City Court and administrative offices, as well as the Clocktower, an alternative art exhibition and studio space.

 The clock has four dials. The huge movement, built by E. Howard of Boston, has a seven-foot pendulum and is maintained and set weekly by Marvin Schneider, the city's clockmaster, who, with his partner, spent his spare time over a ten-year period restoring the clock to working order.

 This is a wonderful space. The clock dials, of transparent and translucent glass, filter the light into a small room in which the clock movement sits in the center in a glass case, like a precious object in a museum. Lower Manhattan surrounds you, but in here the loudest sound is the measured click of the clock every two seconds.

SUGGESTED READINGS

Bone, Kevin, ed. *The New York Waterfront: Evolution and Building Culture of the Port and Harbor.* New York: Monacelli, 1997.

Brooklyn Division of Water Supply and I. M. deVarona. *History and Description of the Water Supply of the City of Brooklyn.* Brooklyn Commissioner of City Works, 1896.

Buttenweiser, Ann L. *Manhattan Water Bound.* New York: New York University Press, 1987.

City of New York, Department of Water Supply, Gas and Electricity. *The Water Supply of the City of New York.* New York, 1939.

Condit, Carl W. *The Port of New York.* Chicago: University of Chicago Press, 1980.

Cooper, Linda Gilbert, ed. *A Walker's Guide to the Old Croton Aqueduct.* Staatsburg, N.Y.: New York State Office of Parks, Recreation and Historic Preservation, [1988?].

Goldberger, Paul. *The City Observed: New York; A Guide to the Architecture of Manhattan.* New York: Vintage, 1979.

Granick, Harry. *Underneath New York.* 1947. Reprint with an introduction by Robert E. Sullivan Jr. New York: Fordham University Press, 1991.

Greenhill, Ralph. *Engineer's Witness: A Photographic Panorama of Nineteenth Century Engineering Triumphs.* Ontario: Coach House; Boston: Godine, 1985.

Halbfinger, David M. "Trying to Save Ellis Island, The Neglected 'Sad Side.'" *New York Times,* 16 June 1997, A1 and B3.

Hood, Clifton. *722 Miles: The Building of the Subways and How They Transformed New York.* New York: Simon & Schuster, 1993.

Hudson River Museum of Westchester. *The Old Croton Aqueduct: Rural Resources Meet Urban Needs.* Yonkers, N.Y., 1992.

Jackson, Donald C. *Great American Bridges and Dams.* Washington, D.C.: Preservation Press, 1988.

Jackson, Kenneth T., ed. *The Encyclopedia of New York City.* New Haven: Yale University Press, 1995.

Koeppel, Gerard. "A Struggle for Water." *Invention and Technology* 9 (winter 1994): 18–31.

Larkin, F. Daniel. *John B. Jervis: An American Engineering Pioneer.* Ames: Iowa State University Press, 1990.

Leonard, John William. *History of the City of New York, 1609–1909.* New York: Journal of Commerce and Commercial Bulletin, 1910.

Library of Congress. *Historic America: Buildings, Structures, and Sites.* Washington, D.C.: U.S. Government Printing Office, 1983.

Lowe, Jet. *Industrial Eye / Photographs by Jet Lowe from the Historical American Engineering Record.* Washington, D.C.: Preservation Press, 1986.

McCullough, David. *The Great Bridge: The Epic Story of the Building of the Brooklyn Bridge.* New York: Simon & Schuster, 1972.

Milster, Conrad. *Pratt Institute Power Generating Plant: A National Historic Mechanical Engineering Landmark.* New York: Pratt Institute and the American Society of Mechanical Engineers, 1977.

"November 21 Marks the Thirtieth Anniversary of the Verrazano-Narrows Bridge." *From the Archive* (Metropolitan Transit Authority Bridges and Tunnels), autumn 1994.

Oppel, Frank, ed. *Gaslight New York Revisited.* Secaucus, N.J.: Castle, 1989.

Peters, Tom F. *Building the Nineteenth Century.* Cambridge: MIT Press, 1996.

Petroski, Henry. *Engineers of Dreams: Great Bridge Builders and the Spanning of America.* New York: Knopf, 1995.

Reimer, Rudolph. "History of Ellis Island." Typescript. Humanities—History and Genealogy Section. New York Public Library.

Reynolds, Terry S., ed. *The Engineer in America: A Historical Anthology from Technology and Culture.* Chicago: University of Chicago Press, 1991.

Richmond, John Francis. *New York and Its Institutions, 1609–1871: A Library of Information, Pertaining to the Great Metropolis, Past and Present.* New York: E. B. Treat; Chicago: W. T. Keener, 1871.

Salvadori, Mario. *Why Buildings Stand Up: The Strength of Architecture.* New York: Norton, 1980.

Schodek, Daniel L. *Landmarks in American Civil Engineering.* Cambridge: MIT Press. 1987.

Seidel, Peter. *Unterwelten: Orte im Vereborgenen / Sites of Concealment.* Texts by Manfred Sack and Klaus Kemp. Tübingen: Ernst Wasmuth Verlag, 1993.

Seitz, Sharon, and Stuart Miller. *The Other Islands of New York City: A Historical Companion.* Woodstock, Vt.: Countryman Press, 1996.

Seyfried, Vincent F. *The Long Island Railroad: A Comprehensive History.* 6 vols. Garden City, N.Y.: privately printed, 1961–66.

Shaver, Peter D. *The National Register of Historic Places in New York State.* New York: Rizzoli International, Furthermore Press Edition, 1993.

Stokes, I. N. Phelps. *The Iconography of Manhattan Island, 1498–1909.* 6 vols. New York: R. H. Dodd, 1915–28. Reprint. New York: Arno, 1967.

Tauranac, John. *Essential New York: A Guide to the History and Architecture of Manhattan's Important Buildings, Parks, and Bridges.* New York: Holt, Rhinehart & Winston, 1979.

U.S. Department of Transportation, Federal Highway Administration, and New York State Department of Transportation. *West Side Highway Project, Final Environmental Impact Statement.* 2 vols. Albany, 1977.

Wegmann, Edward. *The Water Supply of the City of New York, 1658–1895.* New York: John Wiley & Sons, 1896.

Weidner, Charles H. *Water for a City: A History of New York City's Problem from the Beginning to the Delaware System.* New Brunswick: Rutgers University Press, 1974.

Welcome to Roosevelt Island NYC: Map and Walking Tour. New York: Roosevelt Island Operating Corporation of the State of New York, 1992.

White, Norval, and Elliot Willensky. *AIA Guide to New York City.* New York: Collier, 1978.

The WPA Guide to New York City: The Federal Writers' Project Guide to 1930s New York. 1939. Reprint. New York: Pantheon, 1982.

STANLEY GREENBERG was born in 1956 and raised in Brooklyn, New York. He attended Stuyvesant High School, and received a bachelor of arts in art history from the State University of New York at Stony Brook and a master's degree in public administration from Syracuse University. He worked in New York City government for seven years before becoming a full-time photographer, and he has received grants from the Graham Foundation, the New York State Council on the Arts, and the New York Foundation for the Arts. His work has been exhibited at Columbia University and Cooper Union and is in several public collections, including those of the Metropolitan Museum of Art, the Brooklyn Museum of Art, and the Los Angeles County Museum of Art. His work was installed in the New York City subway system in 1997 and 1998. Mr. Greenberg's work is represented by Yancey Richardson Gallery, New York. He lives in Brooklyn with his wife, Lynn, a public high school teacher, and their daughter Yelena.

THOMAS H. GARVER was born in Duluth, Minnesota, in 1934. He received a bachelor of arts in psychology from Haverford College and a master's degree in art history from the University of Minnesota. For nearly thirty years he worked as a curator or director of a number of American art museums, which included the founding directorship of the Newport Harbor Art Museum (now the Orange County Museum of Art) in Newport Beach, California. He has organized many exhibitions of modern and contemporary painting, sculpture, and photography, including "Just before the War: Urban America as Seen by the Photographers of the Farm Security Administration," and "Twelve Photographers of the American Social Landscape." He is the author of more than forty exhibition catalogues and two books, including *The Last Steam Railroad in America: Photographs by O. Winston Link.* He is presently an independent curator and writer living in Madison, Wisconsin.

INVISIBLE NEW YORK
by Stanley Greenberg

Designed by Glen Burris, set by the designer in Filo-
sofia, and separated and printed on 128 gsm Japanese
matte art by C & C Offset Printing Company, Inc.

Library of Congress Cataloging-in-Publication Data

Greenberg, Stanley, 1956–

Invisible New York : the hidden infrastructure of
the city / Stanley Greenberg ; with an introductory
essay by Thomas H. Garver.

 p. cm.—(Creating the North American
landscape)

Includes bibliographical references (p.).

ISBN 0-8018-5945-X (alk. paper)

1. Public works—New York—New York—Pictorial works.
I. Garver, Thomas H. II. Title. III. Series.

TA25.N72G74 1998

779'.4747'1—dc21 98-5701 CIP